IMAGES
of America

MOUNT VERNON
PLACE

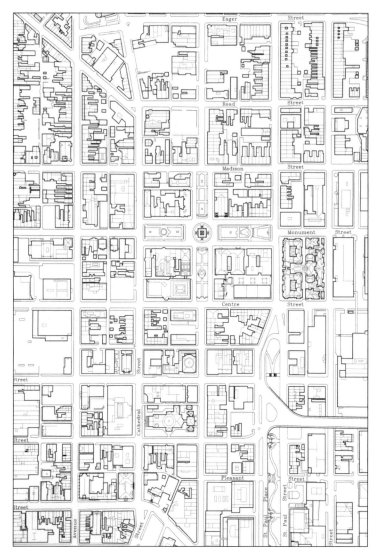

Like intricate inlay, the pattern of Mount Vernon Place emerges from the details of this finely drawn map of Baltimore. Intricacy does not of itself imply fragility, but it always requires delicacy and care. For too long, the area has been under siege, at times—far too frequently—by the very forces that should have arrayed to protect it. This map helps to put Mount Vernon Place in relation to the city around it. But it can only hint at the variety and complexity and unique phenomenology of this extraordinary urban space. To know *where* Mount Vernon Place lies, you may require a map. To know *what* it is, however, you will need something more, something we hope you will begin to find in the pages to follow. (Courtesy of the Baltimore City Department of Planning.)

ON THE COVER: The human face that stares so intently here is now gone, along with the exuberant truck with its proud profile. Despite all of its extraordinary appurtenances, the Olmsted plan no longer remains. In unexpected ways, however, the monument to Chief Justice Roger B. Taney, with its associations to William T. Walters and William Henry Rinehart, takes us back to the origins of Mount Vernon Place. It may take us in unexpected directions as well. It is like a thread through the past, a thread through Mount Vernon Place itself. (Courtesy of the Enoch Pratt Free Library.)

IMAGES
of America

MOUNT VERNON
PLACE

Bill Wierzalis and John P. Koontz

ARCADIA

Published by Arcadia Publishing
Charleston SC, Chicago IL, Portsmouth NH, San Francisco CA

Printed in the United States of America

Library of Congress Catalog Card Number: 2006920124

For all general information contact Arcadia Publishing at:
Telephone 843-853-2070
Fax 843-853-0044
E-mail sales@arcadiapublishing.com
For customer service and orders:
Toll-Free 1-888-313-2665

Visit us on the Internet at www.arcadiapublishing.com

*To architect Aldo Ligabue, my father-in-law, who helped me to look at the world in
a different way.*

—Bill Wierzalis

*To Mrs. Jacqueline Niedenthal, who taught the fourth and fifth grades
at Beechfield Elementary School #246 in Baltimore. To her pupils she gave
abundant gifts, including grace, refinement, and a deep engagement with culture.
After nearly 50 years, she continues to cast a bright and inextinguishable light.*

—John P. Koontz

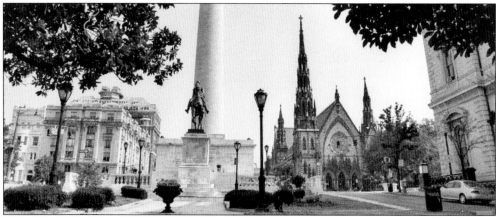

Nowhere else can one so freely and peacefully partake of such bounteous space as Mount Vernon
Place. Once prized by the elite, it was never entirely a private preserve. For generations, it has
been a common venue for common people to pursue common goods. Its intention was remarkably
plain—to honor an indispensable man—but time has endowed it with fathomless depths of meaning.
It makes its appeal as much to one's character as to one's taste. (Courtesy of Bill Wierzalis.)

CONTENTS

ACKNOWLEDGMENTS

Like hapless prodigals on a spree, we amassed a dizzying number of debts in a very short time. Although we gladly and gratefully list them here, a mere sequence of names conceals as much as it discloses. We cannot adequately convey to readers the spontaneity and the scale and the depth of this warm assistance and kindness. We hope that those who generously dispensed them know. We owe them a great debt.

This project would never have taken shape without the advice and support of Jeff Korman, manager of the Maryland Department at the Enoch Pratt Free Library, and his wonderful staff: Don Bonsteel, Layne Bosserman, Nancy Derevjanik, William Jones, Lee Lears, and Kristy Zornig.

We thank: Silvia Agachinsky, Steve Bartley, Lauren Bobier, Sam Boxeley, Janine D'Adamo, John Dorsey, Vincent Fitzpatrick, Tom Guidera, Steve Hahn, Wanda B. Hall, Brian Hefer, William Hollifield, Jim Hull, Bill Johnston, William Jones, Lisa Keir, Paul Kelley, Mary Ann Merriam Koontz, Mary McLanahan, Roger Marks, Diana E. Murnaghan, J. Richard Nickson, Rev. Douglas Pitt, James Reaves, Walter Schamu, Edwin Schell, Steven Sutor, Claudia Thayne, Ron Thayne, Rev. Frederick S. Thomas, Jane Toller, David Turrettini, Patricia Turrettini, Armanda Ligabue Wierzalis, and Marsha Wright Wise.

A photography commission on a snowy day in January 2005 provided the spark that was eventually channeled into the contemporary photographs in this book. For this, Bill Wierzalis thanks Bruce Bodie, co-owner of City Café.

REFERENCES

Beirne, Francis F. *Baltimore . . . A Picture History, 1858–1968.* Baltimore: Bodine and Associates, Inc., 1968.

Brugger, Robert. *The Maryland Club: A History of Food and Friendship in Baltimore, 1857–1997.* Baltimore: The Maryland Club, 1998.

Dilts, James D. and Catharine F. Black, eds. *Baltimore Cast-Iron Buildings and Architectural Ironwork.* Centreville, MD: Tidewater Publishers, 1991.

Dorsey, John. *Mount Vernon Place: An Anecdotal Essay.* Baltimore: Maclay and Associates, Inc., 1983.

Dorsey, John and James D. Dilts. *A Guide to Baltimore Architecture.* 3rd ed. Centreville, MD: Tidewater Publishers, 1997.

Dorsey, John and James DuSel. *Look Again in Baltimore.* Baltimore: The Johns Hopkins UP, 2005.

Hart, Richard H. *Enoch Pratt: The Story of a Plain Man.* Baltimore: Enoch Pratt Free Library, 1935.

Johnston, William R. *William and Henry Walters, the Reticent Collectors.* Baltimore: The Johns Hopkins UP, 1999.

Jones, Carleton. *Lost Baltimore: A Portfolio of Vanished Buildings.* Baltimore: The Johns Hopkins UP, 1993.

Mitchell, Alexander D. IV. *Baltimore Then and Now.* San Diego: Thunder Bay Press, 2001.

Olson, Sherry H. *Baltimore: The Building of an American City.* Baltimore: The Johns Hopkins UP, 1980.

Pennoyer, Peter and Anne Walker. *The Architecture of Delano and Aldrich.* New York: W. W. Norton and Company, 2003.

Stockett, Letitia. *Baltimore: A Not Too Serious History.* Baltimore: Grace Gore Norman, 1936.

INTRODUCTION

In the early summer of 1905, Henry James found himself walking quite alone in Mount Vernon Place. This aging, expatriate author, midway through a nostalgic but revelatory sojourn down the Eastern Seaboard, found himself, as he puts it, unexpectedly "left in possession" of all that he could see. Caught in a kind of reverie, he imagines the square as a drawing room, which he inspects with the casual regard of a "visitor as yet unintroduced." He examines all of the objects readily at hand and then turns to the Washington Monument. To him, it is like "some vast and stately old-fashioned clock, a decorative 'piece,' an heirloom from generations now respectably remote, occupying an inordinate space in proportion to the other conveniences."

This metaphor is, of course, preposterous. It is too readily attuned to the coziness and complacency of a generation that has in its turn become respectably remote. The image of the drawing room feels apt, but the Washington Monument does far more than merely keep time in an "inordinate space." It silently but insistently shapes the time and the place, lending character and content to each. James is indeed alert to the temporal and to tradition, crucial dimensions to the enduring power of the place. But in his struggle to come to terms with it, he reduces a multivalent space to a singular element—the domestic—which doubtless seemed dominant when he wrote. Some of Baltimore's most prominent families had lived there, and in 1905, a few still remained. Today they have all gone. Yet Mount Vernon Place continues.

Its name is slightly misleading. While it is a distinct location, those borders are not delineated on any surveyor's map. It is not a single, simple place. Rather it is a medley of places, where human interests and aspirations converge in a felicitous whole.

In the following pages, we present images and reflections on six distinct spaces—civic, sacred, aesthetic, cultural, domestic, and commercial. Recognizing that others might make different emphases, we offer this as a logical and, we hope, helpful way to view Mount Vernon Place and to reflect on the ways it perpetuates what the poet Wallace Stevens has called the "blissful liaison" between people and place.

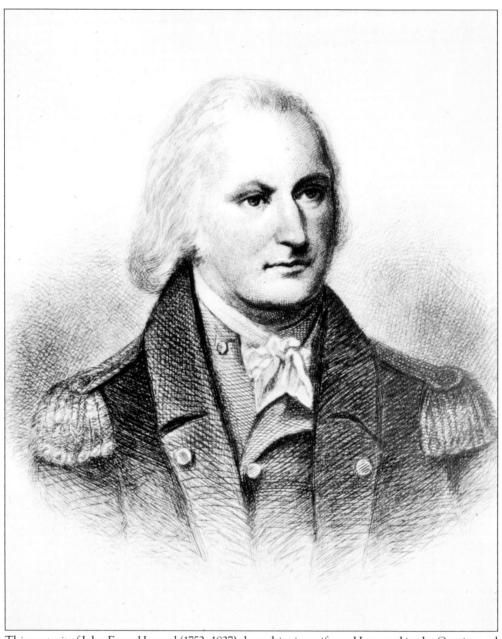

This portrait of John Eager Howard (1752–1827) shows him in uniform. He served in the Continental Army from 1776 until 1781, when the injuries he suffered at the battle of Eutaw Springs effectively ended his military career. He was then in his 20s. Here he appears to be somewhat older. Although he gained a national reputation as a soldier, his impact on Baltimore was primarily political and philanthropic. He helped lay out the city's streets and worked to provide an adequate supply of water. In addition to ground for the Washington Monument, he provided land for Westminster Presbyterian Church, Old St. Paul's Rectory, Lexington Market, the University of Maryland, and part of the Cathedral of the Assumption. Undoubtedly a man of remarkable abilities and character, he is remembered today—perhaps unfortunately—more indirectly by their traces than directly by their substance. (Courtesy of the Enoch Pratt Free Library.)

One

A CIVIC SPACE

Public monuments never arise like Venus from the sea. In democracies, they commonly appear in the wake of strong and deep mentalities. When you look at the monuments proposed and erected today, you might be led to conclude that we live in a mournful age, one marked by grief, absence, or loss. Monuments, in our time, seem to have become a civic recompense.

Clearly Baltimore's monument to George Washington is different. True, it was conceived and built after his death. But it neither mourns nor grieves. Rather than lamenting his absence, it serenely asserts his continuing presence. Indeed the area came to be called Mount Vernon Place, no doubt because, in memory and example, George Washington dwelt there.

His presence is dignified but not reclusive. This is partly the achievement of Robert Mills, the architect responsible for the initial design. But it is also the result of a series of fortuitous and happy decisions transforming the monument, initially conceived as an assertion of triumph, into a gracious embodiment of virtue.

There is, to be sure, a connection to Maryland, which may have ultimately guided the decision to depict Washington's resignation at Annapolis on December 23, 1781. To understand its effect, we have the account of James McHenry, who had served as an aid to both Washington and Lafayette. In the Continental Congress at the time, he wrote to Margaret Caldwell on that unprecedented day:

> The events of the revolution just accomplished—the new situation into which it had thrown the affairs of the world—the great man who had borne so conspicuous a figure in it, in the act of relinquishing all public employment to return to private life—the past—the present—the future—the manner—the occasion—all conspired to render it a spectacle inexpressibly solemn and affecting.

"Solemn and affecting." The builders could not have known these words of McHenry. But they felt them to the core. They erected a worthy structure to express them to future generations.

In a recent speech, the journalist Richard Brookhiser noted that Washington's work is "unfinished." This enduring monument admonishes us of this truth. But it also invites us to continue his noble task.

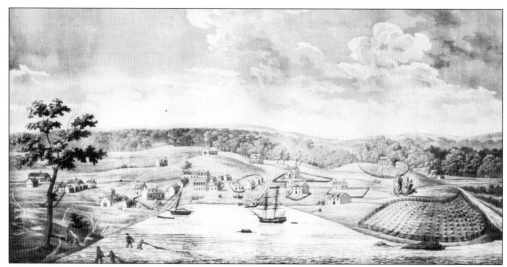

This print of Baltimore in 1752 is taken from a sketch by John Moale, as corrected by Daniel Bowley. It was published in 1817 by E. J. Coale of Baltimore. Note the fisherman displaying a net in the foreground, near the mouth of Cold Spring. In the harbor, a merchant ship is at anchor, while a boat containing a group of men, perhaps its crew, rows apparently toward land. The lithograph gives one a sense of the topography and natural resources of the land as it begins its development into a major metropolis. (Courtesy of the Enoch Pratt Free Library.)

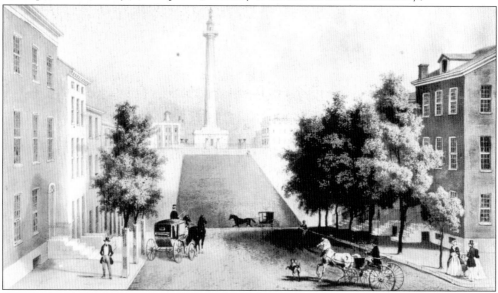

Ostensibly a view of the Washington Monument, this print, dating from around 1848, is a joyous depiction of upper-class, leisured urban life. All seems unalterably right with this world. The horse and carriage trot swiftly across the center of the image, heading west on Centre Street with an abandon that seems carefree, not rushed. In the foreground, a dog engages in a frisky pas de deux with a splendid white horse that seems wary but able to hold its own. Spirits—animal and human—are decidedly high. Some of the houses in the foreground along Charles Street still stand. In the background, to the left of the monument, stands the Greenway House, now the site of the Washington Apartments. To the right stands the house of Charles Howard, now the site of Mount Vernon Place United Methodist Church. (Courtesy of the Enoch Pratt Free Library.)

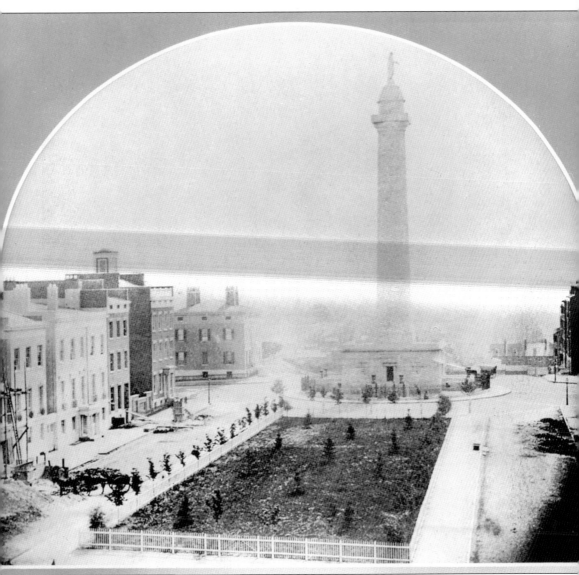

This image of Mount Vernon Place from the late 1840s shows the area under development. The ironwork of Robert Mills (1781–1855) surrounds the monument. The west park has been laid out, and landscaping is underway. A house—now 14 West Mount Vernon Place—is under construction. George Small, who has made his fortune in shipping, will be the first occupant. The Howard house, where Francis Scott Key (1779–1843) died, is still standing. It would be razed to make way for Mount Vernon Methodist Episcopal Church. (Courtesy of Diana E. Murnaghan.)

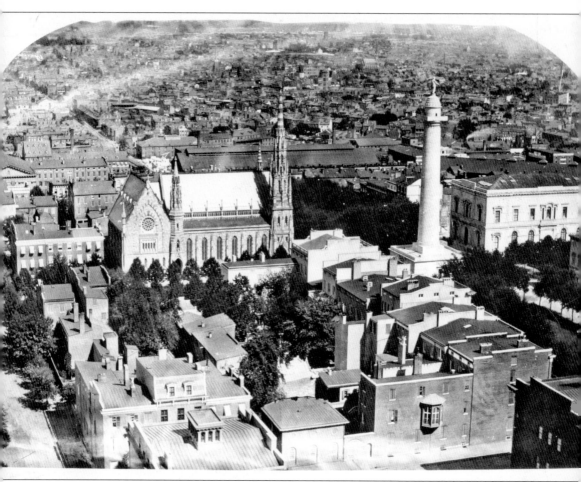

William H. Weaver took this photograph from the scaffolding fronting the spire of First Presbyterian Church in 1873. He climbed the nearly completed steeple of the First Presbyterian Church at Park Avenue and West Madison Street. It gives some sense of why the residents initially regarded Mount Vernon Place Methodist Episcopal Church with disapproval. It dominates the space, and its design is out of character with that of the other buildings. Despite this, it has been constructed, dedicated, and occupied. We see it here at its most audacious. (Courtesy of the Enoch Pratt Free Library.)

George Washington beams with a mixture of amusement and satisfaction over this vignette of Mount Vernon Place in the late 19th century. He presides like a guardian angel. On one level, this conjunction of images is surreal. Yet in a triumph of the mental over the retinal, most people would have made the connection immediately. The course of visual arts in the West during the 20th century has attuned us to such odd conjunctions and their delightful implications. One wishes that Marcel Duchamp had known this card. He doubtless would have deftly exploited the image to highlight its implicit absurdity. (Courtesy of the Collection of William Hollifield.)

MT. VERNON PLACE, BALTIMORE, MD.

Try...

STANDARD SALT.

"It's Pure"

5 CTS.
AT YOUR GROCER

The link between Mount Vernon Place and salt may not be readily apparent. It is certainly not well understood. But it must have been deemed powerful enough to warrant distribution of the card shown here. Perhaps it was meant as a keepsake. If so, it worked. The card doubtless survives because it conveyed this image, not because it promoted that commodity. (Courtesy of the Collection of William Hollifield.)

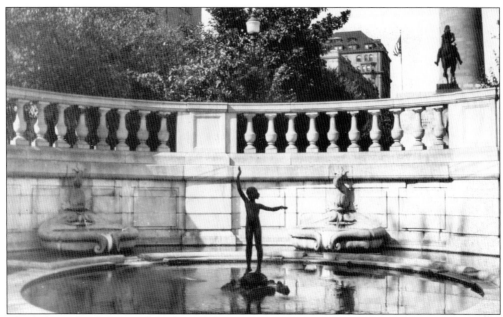

The balustrade of the south park in the Beaux-Arts design of Carrere and Hastings winds in concert with the thick foliage to give a feeling of seclusion to the fountain, transforming it—almost literally—into a welcoming and refreshing urban oasis. The joie de vivre of Edward Berge's *Sea Urchin* animates the scene with a weird extravagance. Berge (1876–1924), whose parents had a marble and granite shop near the Baltimore Cemetery, was a member of the first class of the Rinehart School of Sculpture. (Courtesy of the Enoch Pratt Free Library.)

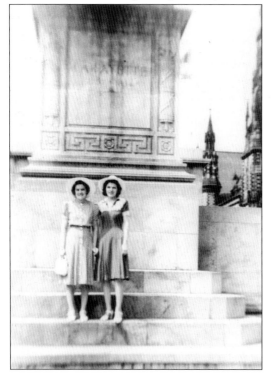

This snapshot dates from July 7, 1940. It is touching in its simplicity and lack of pretension. The women seem unaffected in their modest summer attire, which nicely complements the neoclassical proportions of the south park. Notice the fasces on the pedestal of the Lafayette Monument, which echo Robert Mills's design for the gates of the Washington Monument. (Courtesy of the Collection of William Hollifield.)

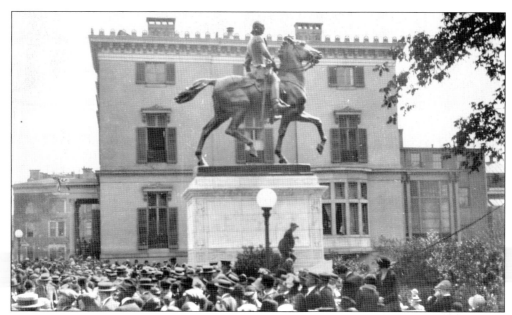

Lafayette, mounted gallantly on his fulsome steed, displays a certain insouciance while parading above the crowd that has gathered to celebrate the dedication of the monument, which is the work of Andrew O'Connor (1874–1941). It was unveiled in 1924. The monument was conceived at a time when fellow feeling with the French allies in World War I, whose conflict with the Germans was perceived to be a struggle for liberty, was strong. It portrays Lafayette at the age of 19, when Congress commissioned him major general of the Continental Army in July 1777. (Courtesy of the Enoch Pratt Free Library.)

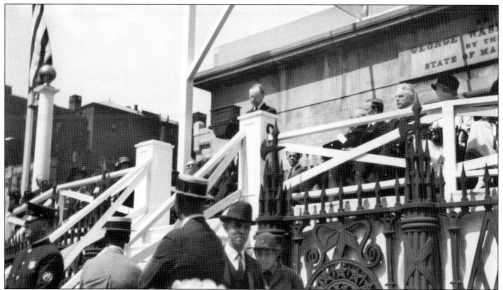

Pres. Calvin Coolidge is shown here speaking at the unveiling of the Lafayette Statue on September 6, 1924. He stands on a dais at the base of the Washington Monument. The photograph—perhaps incidentally—gives a good glimpse of the detail and scale of Robert Mills's design of the gates with the fasces and panels. The fasces motif is repeated on the front pedestal of the Lafayette Statue. (Courtesy of the Enoch Pratt Free Library.)

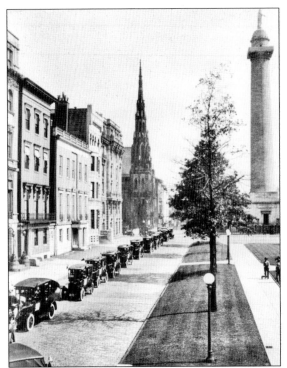

Like blackbirds gleaming and sleek on a telephone wire, cars of the Yellow Cab Company line up along West Mount Vernon Place in a display for the Inaugural Parade in September 1921. The portion of the west park visible here suggests that it is open, airy, and well trimmed. Through the years, the parks have periodically straddled the divide between garden and lawn. Here the west park looks crisp enough for a round of croquet. (Courtesy of Connex/ATC.)

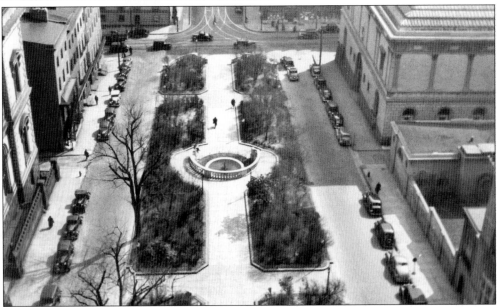

Watching the people walk up or down in this photograph of Washington Place South today, you come to believe that they are—whether or not they know it—enjoying a certain privilege. The city here seems so perfectly poised, so beneficently balanced. When gazing from this perspective, it comes as a shock to realize that here you are encountering not merely a set of buildings surrounding a bit of parkland, but an entire sensibility that was at one time strong enough to shape a city. It is a reminder that in civic planning, as in other aspects of life, modesty can possess an enduring strength. (Courtesy of the Enoch Pratt Free Library.)

In this odd reconfiguration, Enrico Causici's (1790–1835) statue of Washington has been ignominiously excised and replaced with the encircled initials of the American Wholesale Company. In an amusing convergence—one would like to think that the engraver puckishly intended this—the letter "W" stands directly atop Mills's column, here crudely skewed. The text on the token, symbolically balanced between less and more, is silent about quality. The shoddy workmanship says all one needs to know about that. (Courtesy of the Collection of William Hollifield.)

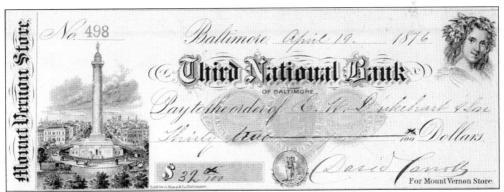

This draft, dated April 19, 1876, and drawn on the Third National Bank of Baltimore, has interest because it depicts Mount Vernon Place and dates from the nation's centennial year. In 1872, the bank's office at South Street was relieved of over $220,000 in what one account described as "decidedly the most bold, daring, and well-planned, well-executed and successful bank robbery that has ever been perpetrated in Baltimore or perhaps in the United States." One hopes the Mount Vernon Store was more tranquil—and secure. (Courtesy of the Collection of William Hollifield.)

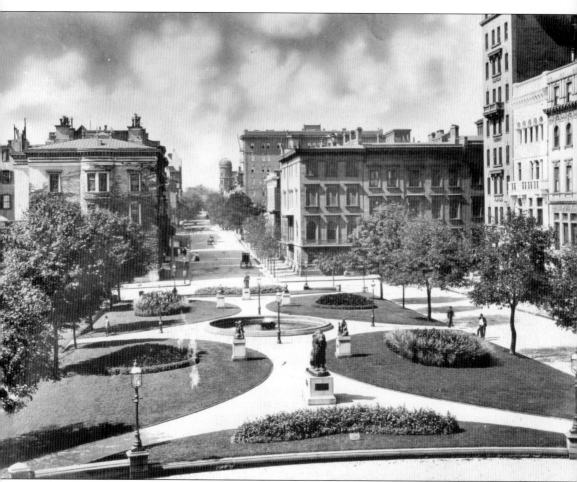

This is how Mount Vernon Place looking west appeared around 1910. The townhouses on the 700 block of Cathedral Street are to the right, the Garrett Mansion on the left. The graceful and fluid geometry of the Olmsted design is nicely captured in this photograph, which shows the sculptures of Antione Louis Barye (1796–1875) grouped in a pleasant ensemble. While it possessed many virtues, the Olmsted plan was replaced with a scheme more in keeping—it was thought—with the neoclassical aesthetic of the monument and its built environs. (Courtesy of the Enoch Pratt Free Library.)

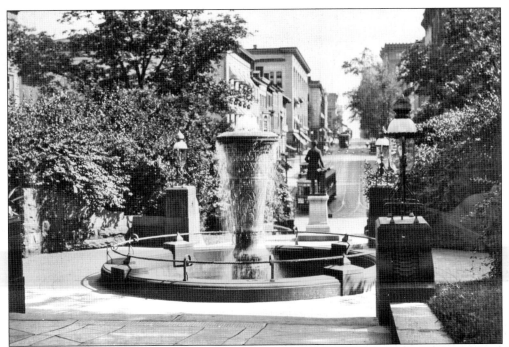

Trolley cars parade up North Charles Street in this view looking south from the south park. The Lilly Fountain glistens in the foreground. The image captures the various textures and proportions of the Olmsted plan. Marqueste's statue of Severn Teackle Wallis stands imposingly on his pedestal at the base of the park. (Courtesy of the Enoch Pratt Free Library.)

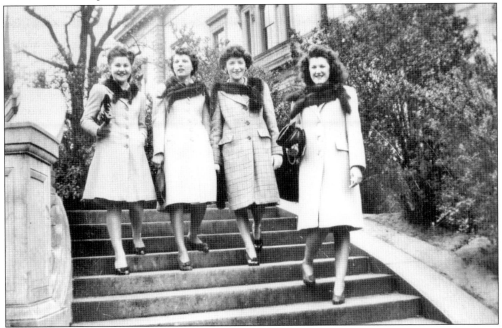

Dressed in their Easter best, four women exude the spirit of the season as they gracefully descend the steps leading to the fountain in the south park on Easter Sunday 1943. The western facade of the Peabody Institute extends behind them. (Courtesy of the Collection of William Hollifield.)

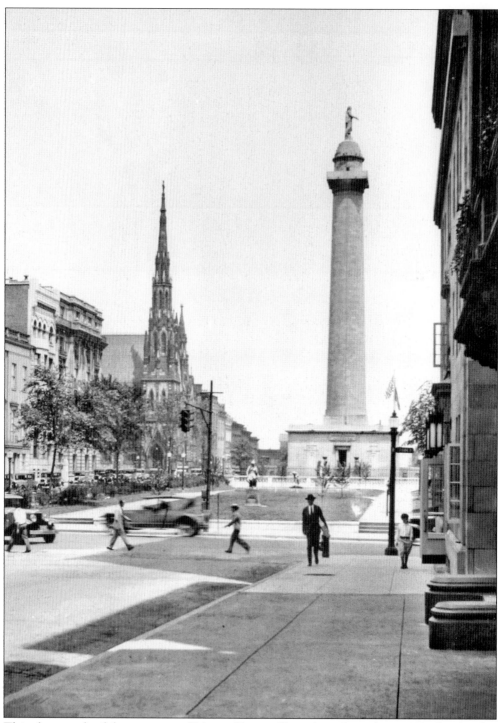

This photograph of the west part of Mount Vernon Place dates from about 1933, shortly after the Garrett Mansion was razed to make way for the apartment building whose Monument Street entrance is visible at right. The traffic light and pole line up almost perfectly with the statuary and do their best to mar an otherwise pleasant vignette. (Courtesy of the Enoch Pratt Free Library.)

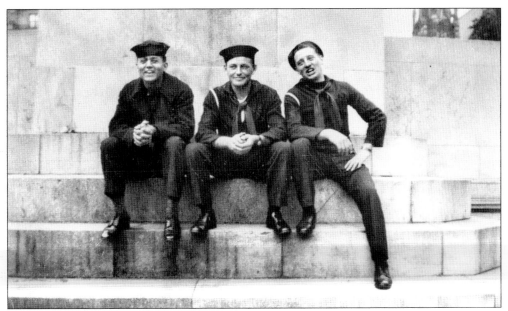

Like characters from a Bernstein-Robbins ballet, these sailors seem to be enjoying their excursion on the town as they pose at the base of the pedestal of the Lafayette Monument. Their joy seems unchoreographed. This snapshot was taken on Easter Sunday 1943. (Courtesy of the Collection of William Hollifield.)

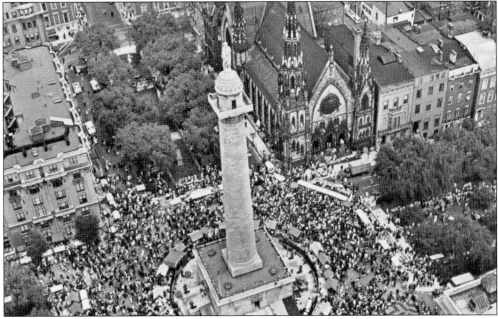

This image of the Flower Mart originally appeared on the front cover of the Baltimore City telephone book in 1968. It nicely captures the nature and scale of this annual gathering, which has become a deeply rooted Baltimore tradition. It is all the more impressive because it was taken during a period of breakdown in civic life. In that perspective, what might initially appear as an anthill becomes, upon reflection, an oasis, a sign of unity and continuity and hope. (Courtesy of the Enoch Pratt Free Library.)

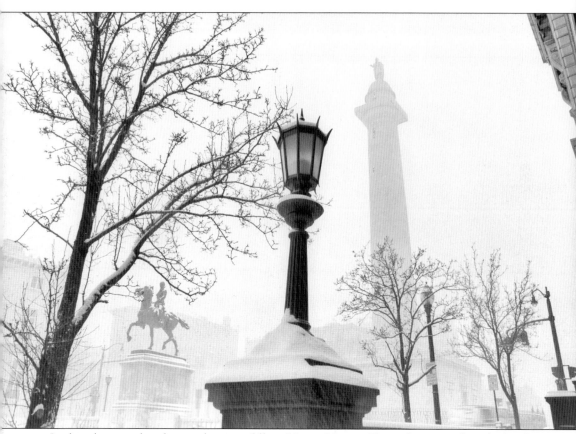

In this photograph, taken as the snow fell on Mount Vernon Place, the atmosphere looks alive and palpable. It seems to suffuse everything—old and new, functional and ornamental—with a gravity-defying lightness of being. Everything, that is, except the graceful, sturdy streetlamp in the foreground. It looks incorrigibly solid. It also looks as if it were the product of a forgotten craft, as if it has emitted its light from time immemorial. In truth, it is the fruit of a fresh aesthetic. It is a new addition to the setting, arriving as part of the recent renovation of the Peabody Institute undertaken by Quinn Evans Architects. Here is proof, if any were required, that there is always room for novelty in a discriminating design. (Courtesy of Bill Wierzalis.)

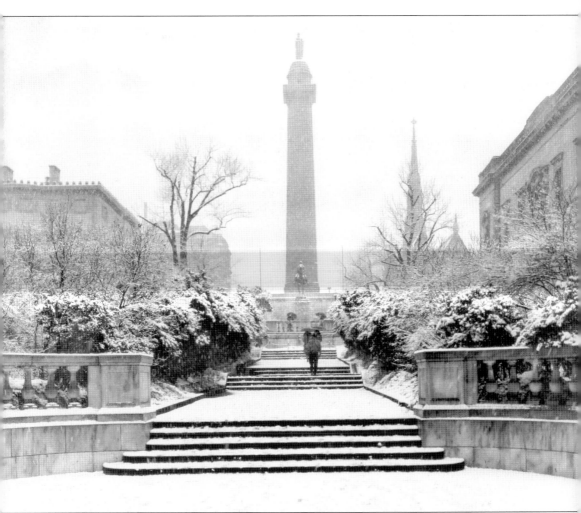

In this photograph, taken around 1939, the seasonal subtleties and variegation of Mount Vernon Place are resolved in stark and unambiguous contrasts. The eye is less distracted by textures and hues and encouraged to concentrate on the sculpted terraces of the south park. Here the built environment seems animated by a balance and harmony that complements the vicissitudes of nature. It has its moods, but they are as transient as nature's. (Courtesy of the Enoch Pratt Free Library.)

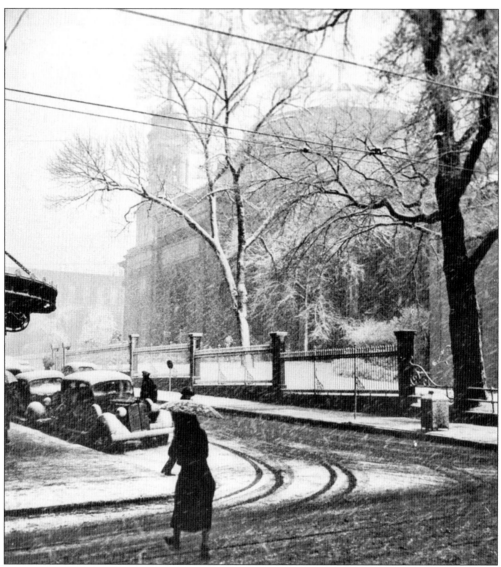

Like a section of a painting by a latter-day Brueghel, this photograph captures a moment of an unremarkable ordeal. A woman with an umbrella leans against the wind as she crosses North Charles Street at West Mulberry Street. A man walking north steps off the curb. Behind him, another man in uniform stands by the driver's side of a snow-covered car. The street is covered with slush. In the background, the Cathedral of the Assumption of the Blessed Virgin Mary seems to hover like an apparition. (Courtesy of the Collection of William Hollifield.)

Two

A SACRED SPACE

Contrasts lend an engaging complexity to the sacred spaces of Mount Vernon Place. They also present startling and wonderful juxtapositions.

Judging by visual evidence alone, when the Mount Vernon Place Methodist Episcopal Church arose, it announced a new era. It was late, but it was unarguably audacious: in style and scale and purpose, it promised a new and different grandeur. According to one account, it required delicate negotiations to ensure that its spires would not exceed the height of the Washington Monument. Here *ecclesia* encounters *civitas*, exhorting us to render to each what we must. It is all the more remarkable that this presumptuousness seems never to have produced an open and outright clash. Somehow, in an environment not distinguished by an extreme eclecticism, the Gothic Revival seems to have settled in quite nicely and to have joined the older Classical Revival club.

It bold facade is a bit deceptive, however. The interior pleases, but it is surprisingly restrained. It is jarring, then, to see that the outward ambitions survive with less gusto within. One can only assume that this is a site of contrasts suited to the liturgical requirements of the faith. This is a space that is ultimately designed for listening, not looking. The stimulated eye is discreetly calmed at the door.

At Grace and St. Peter's Parish, a handsome but unassuming facade only faintly hints at the features within. It was never designed to contain multitudes, yet faith feels palpable here. One recalls John Nairn's wonder at the hidden beauties of a small London church: this is "what happens if you start with one glowing ember and slowly, lovingly build up a fire." The interior glows with grace and piety and provides its faithful with a rich liturgical fare.

Farther afield, one finds churches that reinforce or, in the case of the Roman Catholic Basilica and the First Unitarian Church, anticipate the neoclassical emphasis of Mount Vernon Place. Other essays—some grand, some charmingly modest—on the Gothic Revival style rise just beyond the parks. Venues for worship are as common and as varied as creeds.

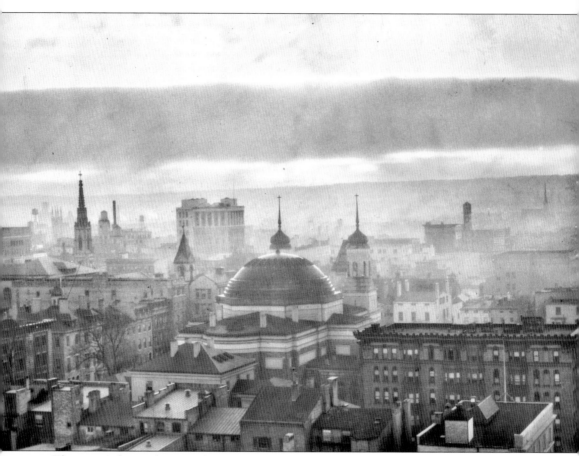

This atmospheric photograph was taken from the Standard Oil Building around 1930. The painted spire of Robert Cary Long Jr.'s (1810–1849) St. Alphonsus Church rises at the left. The tower of the old Enoch Pratt Free Library building is visible just to the right of the dome of the Cathedral of the Assumption. The Rochambeau stands at lower right. Behind it is the house of Robert Goodloe Harper, which was designed by Benjamin H. Latrobe (1764–1820). It was later razed to make way for the new Enoch Pratt Free Library building. (Courtesy of the Enoch Pratt Free Library.)

This tranquil winter scene shows the Cathedral of the Assumption facing a group of houses that were razed to make way for the new building of the Enoch Pratt Free Library. It was taken by Laurence H. Fowler (1876–1971) sometime in the early years of the 20th century. Born in Baltimore, Fowler was raised in Catonsville. He took a degree from Johns Hopkins University in 1898 and graduated in architecture from Columbia University in 1902. In 1906, he opened an office on North Charles Street, where he practiced architecture until his retirement in 1945. (Courtesy of the Enoch Pratt Free Library.)

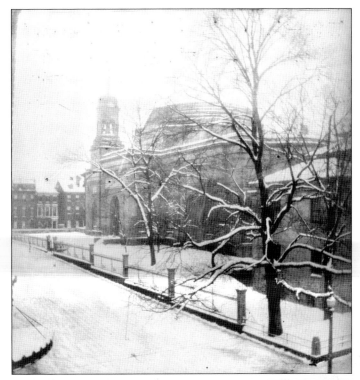

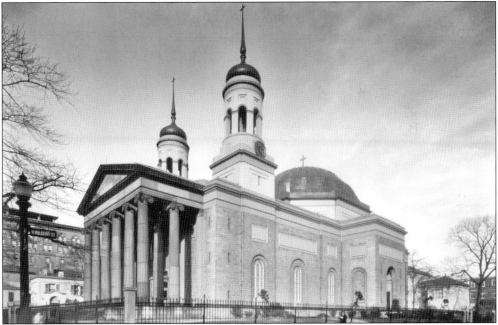

For the design of the Cathedral of the Assumption, architect Benjamin Latrobe offered John Carroll (1735–1815) a neo-Gothic and a neoclassical design. Carroll, temperamentally and theologically a man of the Enlightenment, chose the latter, reasoning that it was more suited to the emerging American ethos. The front portico, with its fluted columns and Ionic capitals, was added in 1863. (Courtesy of the Enoch Pratt Free Library.)

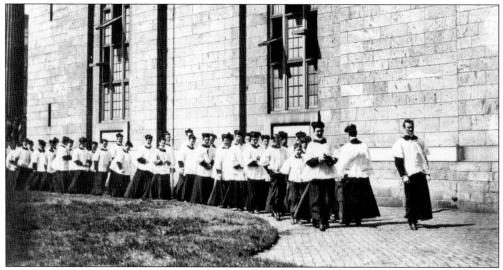

This photograph shows a group of young men in clerical garb walking past the south facade of the Cathedral of the Assumption sometime around 1936. They appear too young to be fully ordained priests and therefore might be seminarians. In any event, it would be quite difficult to assemble a group of that age and that number pursuing holy orders today. (Courtesy of the Enoch Pratt Free Library.)

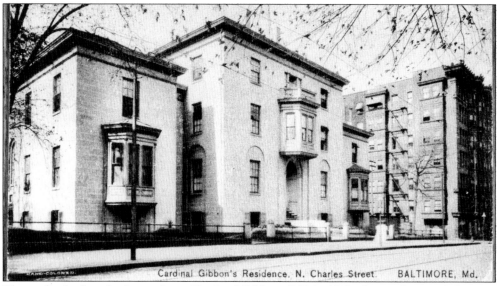

Cardinal Gibbon's Residence. N. Charles Street. BALTIMORE, Md.

The cardinal referred to here is James Cardinal Gibbons (1834–1921), who was born in Baltimore, the son of immigrants. He was ordained in 1861 and, after assignments in North Carolina and Richmond, Virginia, became archbishop of Baltimore in 1877. In 1886, he became the first American to be appointed cardinal. His importance to Catholics in the United States, and to the nation as a whole, went well beyond archdiocesan boundaries. During a period of rapid immigration, he worked to ease ethnic tensions, emphasizing the Church's essential unity. A supporter of the labor movement who backed the struggle for better wages and working conditions, he cautioned against embracing socialism. He was also a respectable palliative to periodic anti-Catholicism, serving as advisor to a number of presidents. The plain simplicity of his dwelling spoke to the faithful of his essential simplicity and piety. (Courtesy of the Collection of William Hollifield.)

Two women, wearing what appear to be hand muffs, stroll north on Charles Street in this photograph by Laurence H. Fowler from the early 20th century. The wall marks the archbishop's garden, contiguous to his residence on the left. Once can see the north spire of the cathedral rising behind it. Here Letitia Stockett reported in 1936, "the townspeople still watch for the first sign of spring—the crocuses." (Courtesy of the Enoch Pratt Free Library.)

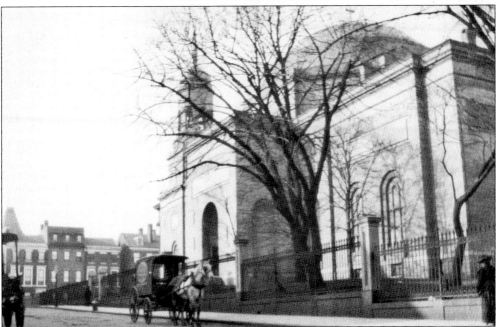

Laurence H. Fowler took this photograph of a house and wagon facing east on Mulberry Street sometime in the early 20th century. The houses of the 400 block of Cathedral Street are visible in the distance. The roof of the old Enoch Pratt Free Library building rises—in view of later events—ominously behind them. (Courtesy of the Enoch Pratt Free Library.)

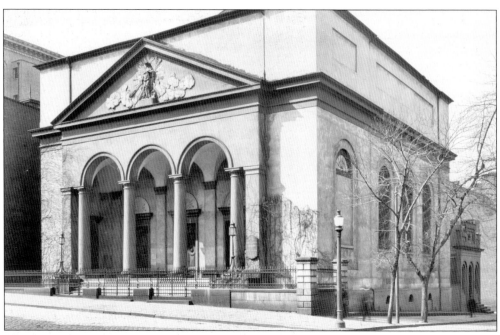

This photograph shows how integrated the building is to the sidewalk and street. Trolley tracks sweep at bottom left. With brick sidewalk, hewn curbstones, and cobblestone streets, the setting seems fully crafted. (Courtesy of the Enoch Pratt Free Library.)

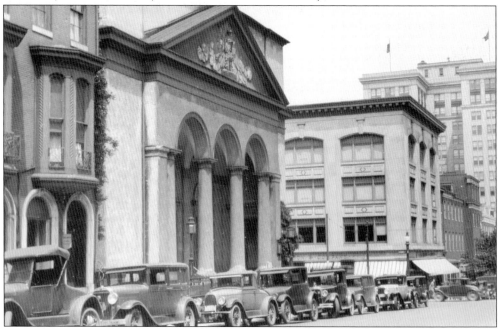

Taken on Franklin Street looking east, this photograph depicts First Unitarian Church surrounded by a phalanx of automobiles. The pace of the street is picking up, and the equilibrium between church and street is nearly disappearing. Designed by Maximilan Godefroy (c. 1770–c. 1837), this building has stood on this corner—in greater or lesser harmony with its environs—since 1818. (Courtesy of the Enoch Pratt Free Library.)

This photograph by an unknown photographer shows the interior of First Unitarian Church after its remodeling in 1893. It is substantially changed from its appearance in 1819 when, during the ordination of Jared Sparks (1789–1866), William Ellery Channing (1780–1842) gave the sermon that is credited with inaugurating modern Unitarianism. The mural of the Last Supper in the chancel above a table, which hints at an altar, seems to suggest that the connections to the period when it was known as First Independent Christ's Church still persist. The lights in the ceiling glow like stars, suggesting that this is heaven's canopy. (Courtesy of the Enoch Pratt Free Library.)

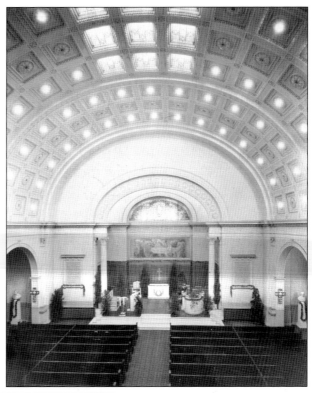

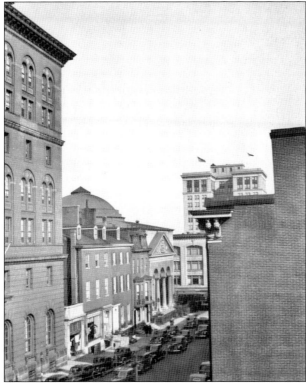

This view was taken by James W. Foster from the second floor of the north end of the Enoch Pratt Free Library in November 1940. The YMCA building is on the left; the Standard Oil Building looms on the center right. The scale of First Unitarian Church appears to shrinking, although it is nicely attuned to the commercial buildings—converted from residences—contiguous to it. The dome, which is not easily viewed from street level, adds a certain grandeur. West Franklin Street, which once teemed with Conestoga wagons heading west, teems with automobiles here. (Courtesy of the Enoch Pratt Free Library.)

St. Ignatius started life as a chapel for students. Both Loyola High School and Loyola College originated here. It has since become a parish, serving a diverse congregation with the special perspective of the Jesuit tradition. Today the complex houses CENTERSTAGE and Saint Ignatius Loyola Academy. (Courtesy of Bill Wierzalis.)

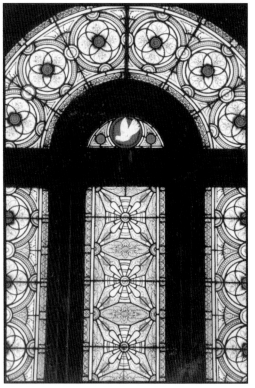

A dove, ancient symbol of the Holy Spirit, has nowhere to alight in this window of St. Ignatius Church. The gentle geometry of this stylized design appears to admit a hypnotic light. The window, designed by Boston's Redding, Baird, and Company in 1884, is part of a group of seven on the East Madison Street side of the nave. Each has a geometric pattern with a roundel at the top. (Courtesy of Bill Wierzalis.)

A sobering example of adaptive use, this building, dating from 1847, was bought by the Third Church of Christ, Scientist, in 1924. It had formerly been the townhouse of William J. Albert (1816–1879), who hosted Abraham Lincoln here when he came to Baltimore to deliver his speech to the Sanitary Fair on April 18, 1864. After purchasing the property, the church altered the facade in what, in all honesty, seems to have been a dismal effort to make the building appear more churchly. Whatever the intention, it enhanced neither the church—which has since departed—nor the neighborhood. (Courtesy of the Enoch Pratt Free Library.)

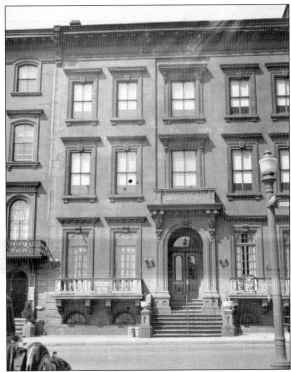

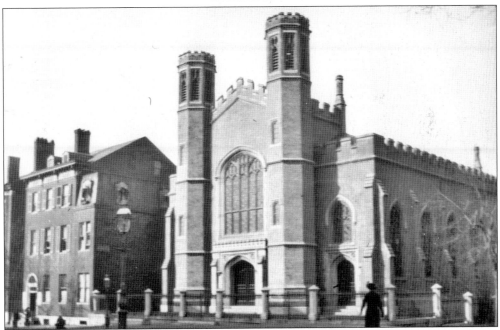

Laurence H. Fowler recorded this scene of the Franklin Street Presbyterian Church on the northwest corner of West Franklin and Cathedral Streets. Here the brick facade is painted to its advantage. One notes touches here and there of a lighter tone, which provides a pleasing contrast. Designed by Robert Cary Long, the building housed a congregation that later merged with the First Presbyterian Church located a few blocks to the north. (Courtesy of the Enoch Pratt Free Library.)

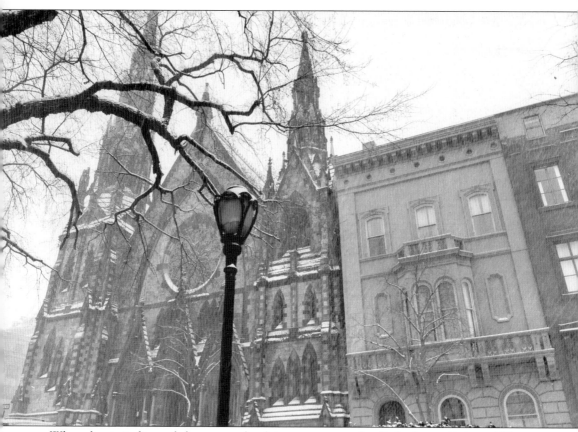

When the eye is diverted above street level, it encounters a view little changed in over 125 years. In this view, Mount Vernon Place United Methodist Church and Asbury House are a study in contrasts but also of a harmony, perhaps unintentionally formed through the horizontal lines. The church's cornerstone was laid on September 26, 1870. According to one contemporary account, "a large audience was in attendance and stood patiently through the whole exercises, which continued nearly three hours." (Courtesy of Bill Wierzalis.)

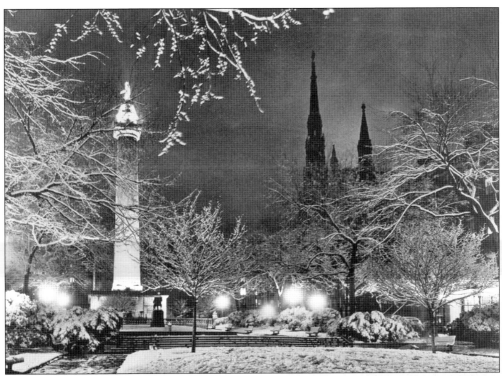

If anyone were to doubt the salutary effect of Mount Vernon Place, all he would have to do is spend a moment or two looking at this photograph. This is an image the poet Wordsworth, whose imagination took him deep into the heart of things, would have instinctively understood. During an early autumn morning on London's Westminster Bridge, Wordsworth, no great lover of cities, wrote, "Never saw I, never felt, a calm so deep." If it is anything, this is surely an image of deep calm. Far from obscuring the beauty of the place, night discloses it in a deep relief. The monument glows as if lit from within. But the spires of Mount Vernon Place United Methodist Church are silhouetted against the night sky like celestial sentries. (Courtesy of Mount Vernon Place United Methodist Church.)

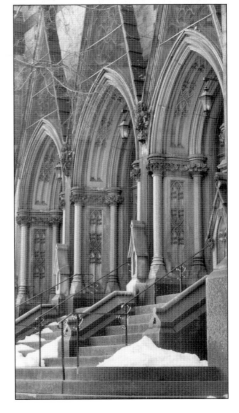

This photograph of the three-arched porch of Mount Vernon Place United Methodist Church captures the sublimity of the design and testifies to its eloquence. Here commentary must yield to admiration. One gets lost in the medley of textures and design features. The entrance to this venerable space suggests a Trinitarian harmony that is at once welcoming and ennobling. (Courtesy of Bill Wierzalis.)

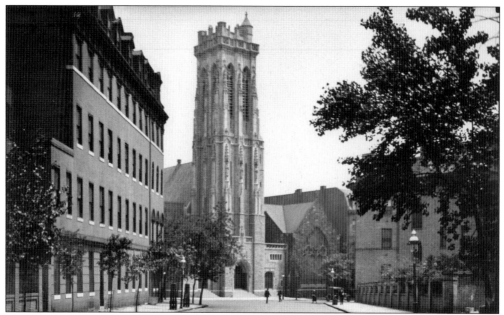

This photograph of Emmanuel Episcopal Church at the corner of West Read and Cathedral Streets shows the splendid "Christmas Tower," which was dedicated on June 27, 1920. It was erected as a memorial to Mrs. H. Crawford Black, who died on Christmas Day. Designed by Woldemar H. Ritter of Boston, the tower retells the story of the Nativity in the sculpture of John Kirchmayer, a Bavarian carver who is also responsible for the magnificent triptych over the altar of the Peace Chapel within. (Courtesy of the Enoch Pratt Free Library.)

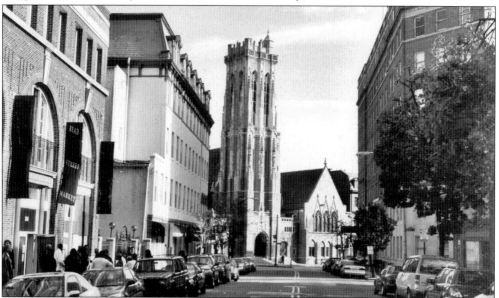

This photograph, recently taken from roughly the same perspective as the vintage photograph, shows the changes in the neighborhood as well as to the facade of Emmanuel Church in the intervening years. The presentation to the eye is a more coherent unity. The edifice still seems entirely in control of the street, despite the plethora of automobiles that seem to have sprung up like mushrooms on West Read Street. (Courtesy of Bill Wierzalis.)

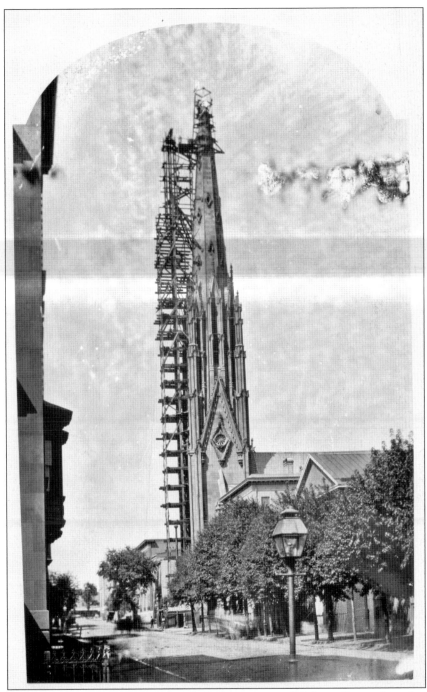

This view of the First Presbyterian Church looking west on Madison Street dates from 1875. The scaffolding adjoins the south side of the steeple, which is nearly complete. The name of the architect who designed it is lost, but the daughter of Edmund G. Lind (1829–1909), the architect responsible for the design of the Peabody Institute, reportedly maintained that he was responsible for it. Lind had worked under N. G. Starkweather (1818–1885) earlier in his career, so the attribution is possible. Note the absence of the corner tower. (Courtesy of the Enoch Pratt Free Library.)

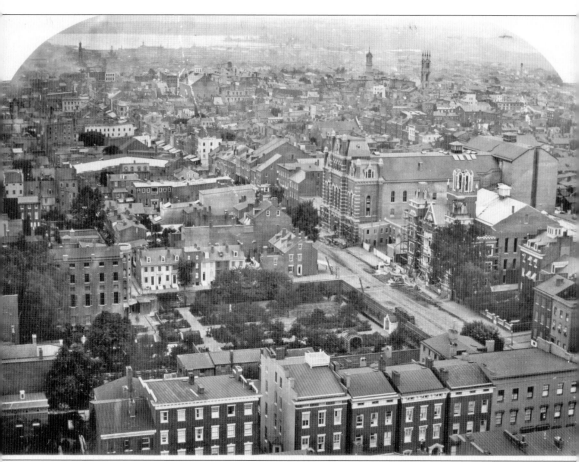

This panoramic view, which William H. Weaver photographed from the scaffolding of the spire of the First Presbyterian Church in 1873, shows Howard Street looking south. The spires of Camden Station and Westminster Presbyterian Church rise in the background. In the middle distance, carriage sheds separate the Academy of Music and City College, still undergoing construction here. In the foreground center is a view of the garden of the Academy of the Visitation. (Courtesy of the Enoch Pratt Free Library.)

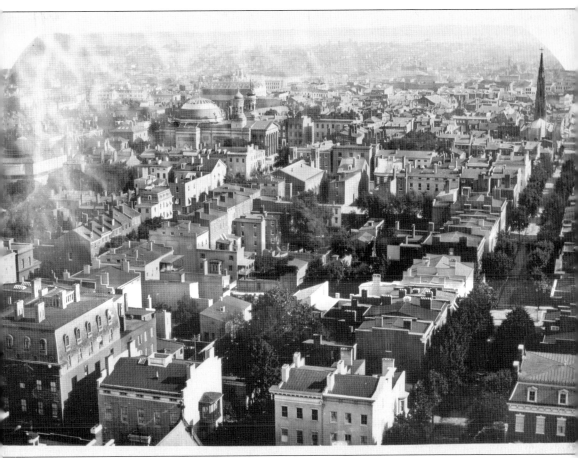

William H. Weaver's view of Baltimore in 1873 shows the character of the neighborhood to the south and west of Mount Vernon Place. The detail around the Cathedral of the Assumption, upper left, is particularly interesting in that it shows Cathedral Street ending at West Mulberry Street. Across West Franklin Street from the cathedral is the old Maryland Club building, since replaced by the YMCA building. The castellated walls and turrets of the Franklin Street Presbyterian Church stand opposite Cathedral Street on West Franklin Street. (Courtesy of the Enoch Pratt Free Library.)

This is a view of the lovely facade of the house adjoining First and Franklin Presbyterian Church on West Madison Street. Known as "The Manse" or "Backus House," it was the residence of Rev. John C. Backus (1810–1884). A graduate of Yale College, he studied theology in New Haven, Andover, and Princeton Theological Seminary and became the rector of First Presbyterian in 1836, when he was barely 25 years old. He served until 1874. He organized the relocation and construction of First Presbyterian at its present location. In 1861, he was elected moderator of the convention that passed the Gardiner Spring Resolutions, one of the most decisive—and disruptive—measures passed in the history of the Presbyterian Church, which had the effect of requiring all pastors to swear allegiance to the federal government. In such a calm setting, this house seems little changed from the time when the Backus family occupied it. (Courtesy of Bill Wierzalis.)

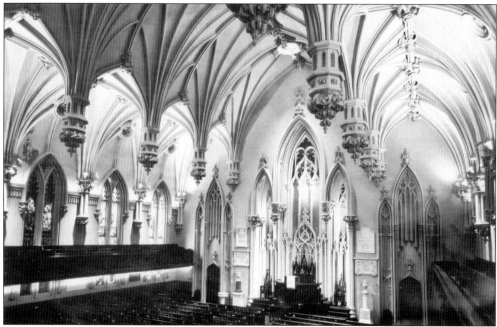

A view of the nave of First Presbyterian Church from the 1950s shows the magnificent plasterwork throughout the interior. In 1981, after suffering water damage and general deterioration, it was restored by Robert and John Giannetti, whose family, originally from Tuscany, has practiced the craft for generations. (Courtesy of the Enoch Pratt Free Library.)

This photograph shows First Presbyterian Church as it stood in 1938. The design is by N. G. Starkweather, who designed a number of important residences and churches in the area, including Trinity Episcopal Church in Towson and St. John's Church in Ellicott City. It was built between 1854 and 1859 and was the culmination of the efforts of the congregation's fourth minister, John Chester Backus, who served nearly 40 years from 1836 to 1875. (Courtesy of the Enoch Pratt Free Library.)

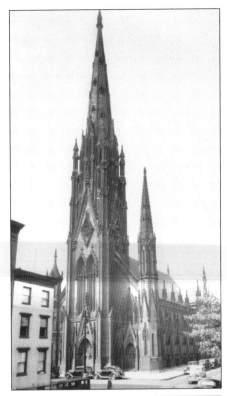

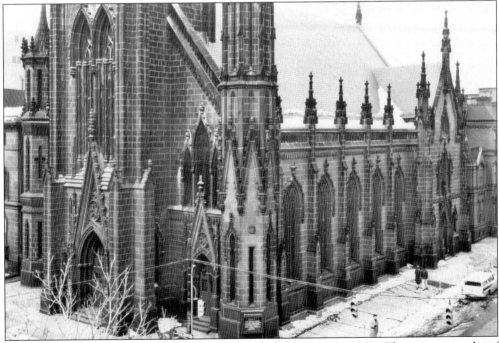

This is a view of the south facade of First Presbyterian Church in the 1950s. The snow-covered roof sets its turrets in high relief. The people on street level provide a useful sense of scale. (Courtesy of the Enoch Pratt Free Library.)

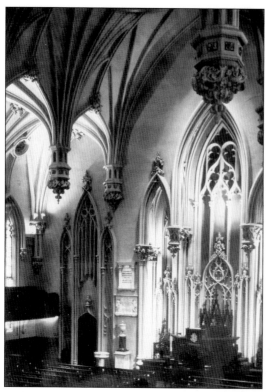

A view of the pulpit end of the nave of First Presbyterian Church shows the plasterwork in great detail. The glue-mold technique, developed after 1840 and involved in creating plaster ornamentation, used horsehair or hemp fiber as a reinforcing material. If a piece cracks, it will not break. The restoration in 1981 returned the ornamentation to its stunning original condition. (Courtesy of the Enoch Pratt Free Library.)

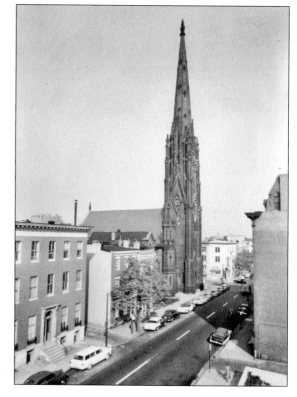

First Presbyterian dominates the skyline in this view looking east down Madison Street in the 1950s. The roof on the Hotel Belvedere rises behind it in the distance. (Courtesy of the Enoch Pratt Free Library.)

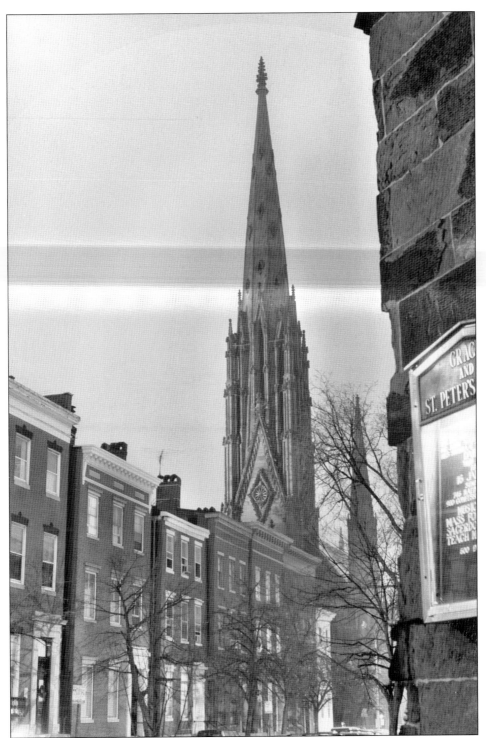

The spire of First and Franklin Presbyterian Church rises above row houses on Park Avenue in this view from Grace and St. Peter's Parish. The scene has the serenity and placidity of a medieval European city. (Courtesy of Bill Wierzalis.)

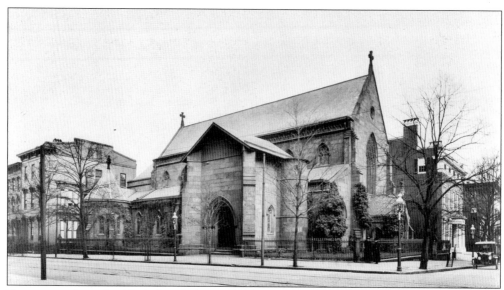

Two women dressed in black, faintly discernible here, pose in front of Grace and St. Peter's Parish in this photograph from the early 20th century. It seems a moment of near-perfect equilibrium in the built environment. The streets are not merely paved but crafted. The streetlights along West Monument Street and Park Avenue seem burnished and bright on this winter's day. This is a picture not only of a building but also of civic and sacred harmony. (Courtesy of Grace and St. Peter's Parish.)

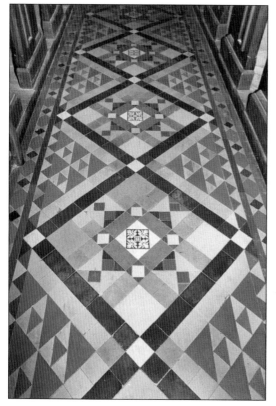

The floor of the nave of Grace and St. Peter's Parish, with its patient and painstaking geometry composed in Minton tiles, gives the space a strong processional quality. The design evinces strength and ingenuity. The repeated pattern becomes the visual counterpart to polyphony. And like this sacred music, the beauty of the tiles instills in the worshipper a greater receptivity to the holy liturgy. It unequivocally states that there is no unworthy space in this house of God. (Courtesy of Bill Wierzalis.)

This evocative photograph shows the Washington Monument framed by the cast-iron fence of Grace and St. Peter's Parish fronting West Monument Street. The view has changed since the construction of the church in 1852, but it beautifully evokes the tempo and texture of the area. The building was designed by J. Crawford Neilson (1816–1900) to house Grace Church. The church's brownstone facade—the first in the city—is visible at the left. (Courtesy of Bill Wierzalis.)

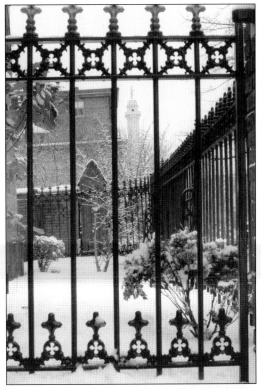

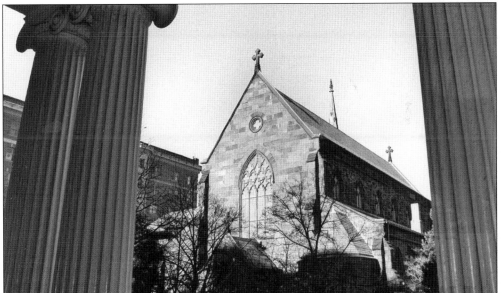

This photograph of Grace and St. Peter's Parish, taken from the front porch of 107 West Monument Street, suggests the connection the church has to its neighborhood. In 1912, the congregation of St. Peter's on Druid Hill Avenue merged with Grace Church. Their congregation, having been incorporated in 1802, was older, but the Grace Church building, which dates from 1852, actually predated theirs. The top of the spire of First and Franklin Presbyterian Church rises above the church's roofline. (Courtesy of Bill Wierzalis.)

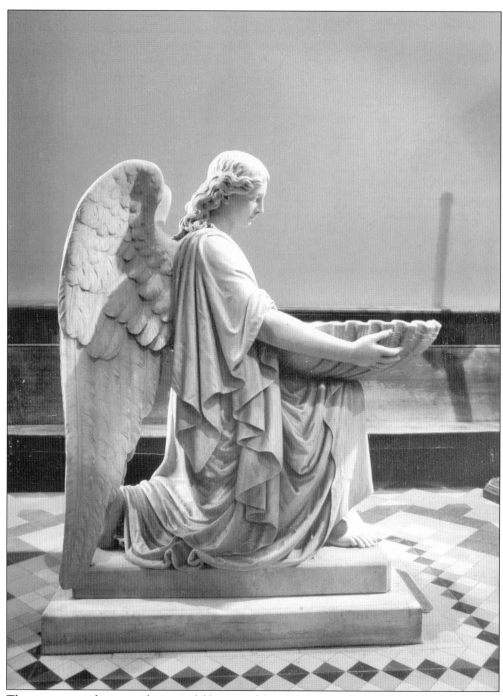

The response in the eye to this graceful baptismal font by the Danish sculptor Bertel Torwaldsen (1768–1844) is all the evidence one needs to rebut the claim that his neoclassical style is unsuited to sacred art. This image is suffused with sacramental grandeur. The genuflecting angel holds a scallop shell, traditionally associated with pilgrimage, which here becomes a potent image of divine agency. The lustrous wings defeat the skeptical eye and seem perfectly accommodated to their sacred subject. (Courtesy of Bill Wierzalis.)

Three

An Aesthetic Space

At Mount Vernon Place, transitions are seamless, but they are never straightforward. Here, when you pass from the sacred to the aesthetic, you undertake more than an idle physical passage. You enter an unusual visual realm.

The array of historical figures—some of whose achievements have passed well beyond memory—gives the parks a funereal air. At the very least, they seem to command deference, which is only a different kind of piety. They may be a source of interest, but they are hardly a source of delight. This sensation is not altogether relieved when encountering the allegorical figures. To comprehend them fully, one must be possessed of an intimidating sensibility or accompanied by an expert guide.

With patience and discernment, however, you discover you have stumbled upon a new Arcadia. It is not readily apparent. But you don't need a visionary eye to see it. You can hear it in the fountains, with their unconstrained joy. This is where the parks—in the west and south especially—come alive. Here childhood frolics among imposing adults, and the feminine gleams among the masculine. Where the monuments are tutelary, the fountains and their sculptures are sportive. During the warm seasons, the murmuring showers and the exuberant forms faintly hint of the numinous. In winter, their surfaces yield to their raiment of snow. It is a place of many moods.

Not all are cheerful. In the west park, Grace Turnbull's *The Naiad*, the most fully realized female form in Mount Vernon Place, is contorted into an abstraction. While formally intriguing, it suggests darker moods and deeper textures in the midst of the fountain's effulgent spray.

Barye's *Seated Lion* presides like a regal presence. Its demeanor suggests it is willing to lie down with the lamb. All of its natural ferocity has composed itself into lofty virtue. When the poet Wallace Stevens wrote, "the whole of the soul / . . . Still hankers after lions, or, to shift, / Still hankers after sovereign images," he was thinking of Sweden, but looking at this imperious image, one knows what he means.

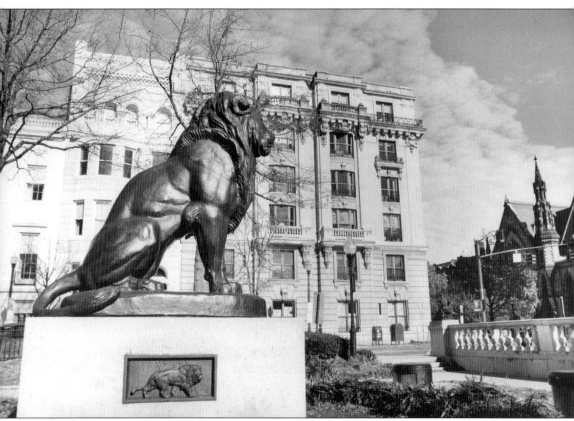

Next to the Washington Monument itself, the sculptures of Antoine Louis Barye define the aesthetic character of Mount Vernon Place. His *Seated Lion*, a copy of an original in the Pavilion de Fiore at the Louvre in Paris, was a gift of William Walters (1819–1894). Sculpted with a keen awareness of its latent power and ferocity, this lion seems dignified and restrained, in keeping with the place's temperament. The symmetry may be fearful, but its aspect is as gentle as a lamb's. (Courtesy of Bill Wierzalis.)

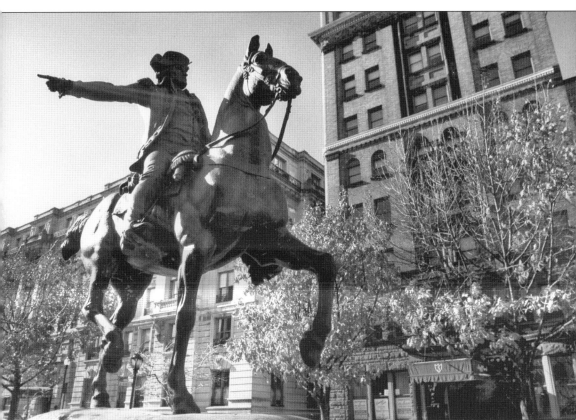

This heroic and somewhat fanciful equestrian statue of John Eager Howard by Emmanuel Fremiet (1824–1910) dates from 1904. It was financed through funds raised by popular subscriptions. The drama and scale were doubtless points of pride to the people who commissioned it. It is a bit misleading, however. Although Howard made his national reputation as a soldier, he was first and foremost an infantryman. At the Battle of Cowpens on January 17, 1781, he secured victory by his innovative infantry maneuvers. William F. Giles would later contend, "This is the first time in the history of war, in which the bayonet was successfully used." Congress awarded Howard the silver medal for gallantry in 1781. He received it in 1790. (Courtesy of Bill Wierzalis.)

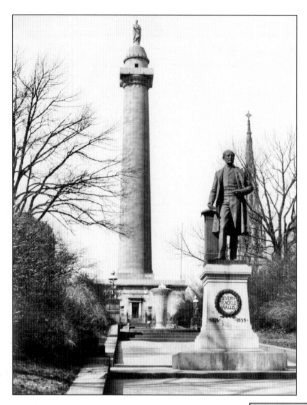

This statue of Severn Teackle Wallis (1816–1894) by Laurent-Honore Marqueste (1848–1920), shown in its original site in the south park, successfully projects his reputation for eloquence. It depicts him as he declaims for the reform of city politics in the period following the Civil War. His enthusiasm for *Don Quixote* may have spurred his idealism. His reform efforts did not endear him to all, leading one admirer to claim that it prevented him from gaining a seat in the U.S. Senate. (Courtesy of the Enoch Pratt Free Library.)

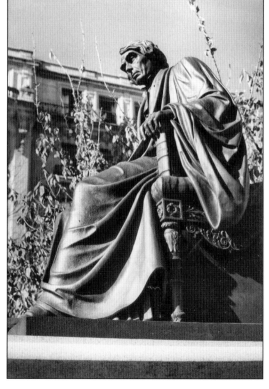

Presented by William T. Walters, this monument to Roger Brooke Taney (1777–1864) is a copy of the original by William Henry Rinehart (1825–1874) in Annapolis. He sits in a richly ornamented chair, resting his left arm on a volume labeled "The Constitution." He wears his judicial robes of office, allowing the sculptor to display his ability with the flow and fold of drapery. Taney, who authored the Dred Scott decision, holds a vexed place in American history, a state of affairs of which he would seem, judging by the expression on his face, to be well aware. (Courtesy of Bill Wierzalis.)

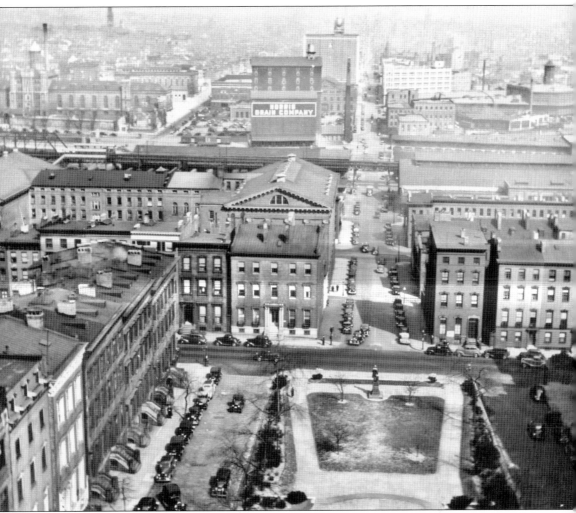

This view shows the interaction of St. Paul and East Monument Streets in 1936. To the left, in the middle distance, one can see the buildings of Loyola College and St. Ignatius Church. The elevated train tracks crossing East Monument Street in the farther distance disappear behind the shed of the Calvert Street Station. In the foreground, Laurent-Honore Marqueste's statue of Severn Teackle Wallis seems like an isolated and solitary figure—much like the Don Quixote he deeply admired—in the bare east park. (Courtesy of the Enoch Pratt Free Library.)

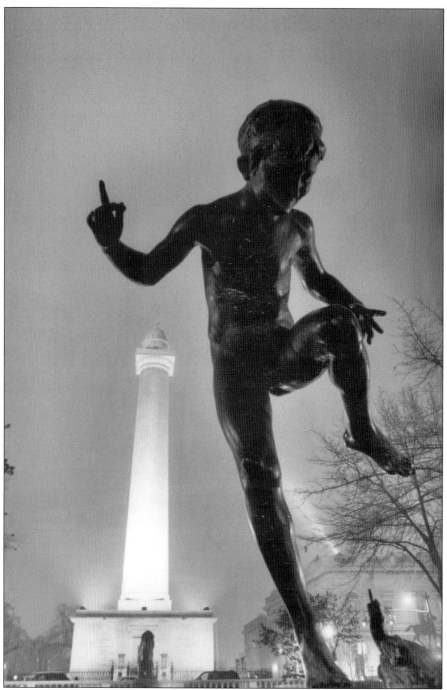

When seen from similar angles, *The Boy and the Turtle* in the west park and *The Naiad* in the east park have strong angularities. Where *The Naiad* seems to turn inward, however, Henri Crenier's (1873–1948) *The Boy and the Turtle* seems perennially frolicsome. The gleeful movement of both boy and turtle—like steps in an unknown ritual dance—seems to be the most natural thing to do under the circumstances. But, in truth, it is very odd. The fountain has become such a familiar presence that one almost doesn't notice how extravagant it is. (Courtesy of Bill Wierzalis.)

A pigeon rests in the shade of the fountain as birds line its lip like sunbathers at the beach. In the foreground is Henry Berge's (1908–1998) rescaled copy of his father's *Sea Urchin*, the original of which is now on the grounds of the Homewood campus of the John Hopkins University. Often called conservative sculptors, the Berges—father and son—here succumb to a certain unabashed exhibitionism that would have surely startled earlier generations of Mount Vernon Place residents. In the scheme of things, it does seem oddly out of place. (Courtesy of Bill Wierzalis.)

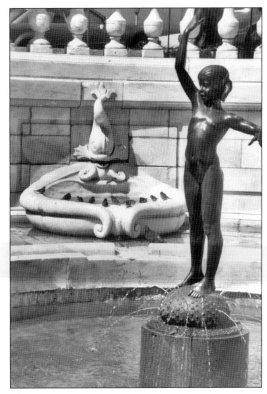

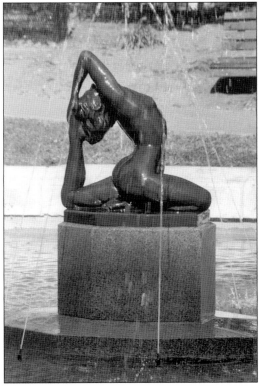

This sculpture by Grace Turnbull (1880–1976) is the only representation of a mature female figure in any of the parks. Seen from this perspective, *The Naiad* seems shaped like a lyre, and thus happily positioned in a fountain in the east park opposite the Peabody. While the conjunction is pleasing, one has questions about the figure, contorted, to the point of pain, into a severe angularity. (Courtesy of Bill Wierzalis.)

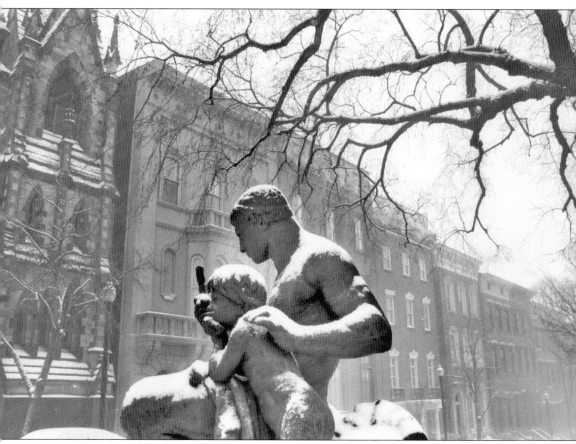

Force, the title of this allegorical group by Barye, seems at first an arbitrary choice. The figures, a strong but ostensibly gentle male and a pensive child, appear to represent nothing so much as repose. They meet the falling snow with stoical detachment and seem to muse over the capriciously varied atmosphere. But this belies their endeavor, which they undertake with a natural nonchalance, of containing the lion, which lies prostrate—for now—at their feet. (Courtesy of Bill Wierzalis.)

You can't see it here, but there is a wild cat snarling with angry teeth beneath the heel of this bringer of order in Barye's *Order*. The scale in this photograph may be misleading, inasmuch as the group is relatively diminutive. But as is the case with most of the allegorical figures punctuating the west and east parks, the idea is timeless and provocative, a perennial necessity for free people. Here he makes it look easy. Would that it were always so. (Courtesy of Bill Wierzalis.)

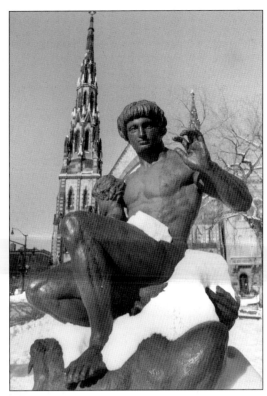

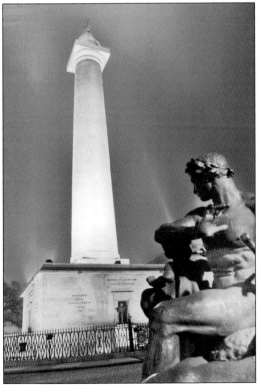

An oversize subject, *War* is actually executed on a smaller scale than this photograph might suggest. It was repositioned nearer to the Washington Monument in the Carrere and Hastings redesign, making its association with Washington's public career more explicit. It is a heroic, even chivalric, conception—a horse is poised to leap as the figure readies his sword for combat. The brutality of the American Civil War had tarnished this ideal, and the war in Europe, proceeding at just about the same time this figure was remounted, would render it completely obsolete as an empowered image. Today it is merely, and perhaps appropriately, decoration. (Courtesy of Bill Wierzalis.)

As he has for generations, Nipper waits faithfully for his master's voice. The sculpture, perched atop the Maryland Historical Society's building across the street, is reflected in the arched window of 605 Park Avenue, where Nipper seems quite at home. In contrast, the floral frieze with the grotesque mask seems agitated. The facade of this house is more exuberant than those of its neighbors. (Courtesy of Bill Wierzalis.)

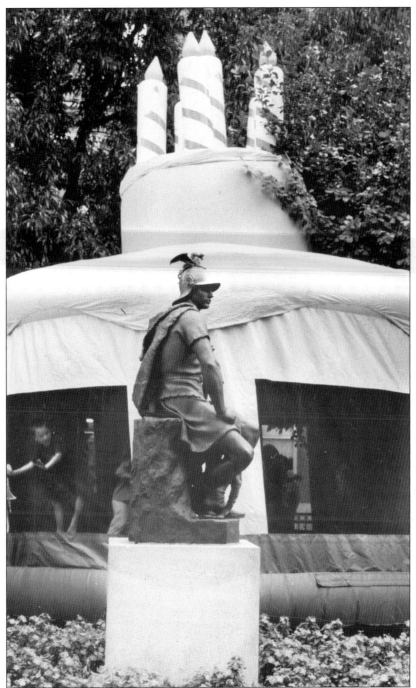

The moonwalk looms like an inflated fortress behind Paul Dubois's (1829–1905) sculpture, *Military Courage*. The candles adorning it even look like surreal turrets. The child on the left may be curious, or he may be wary. But Courage, calm but poised, seems supremely indifferent. He has other matters in mind. His right hand is clenched into a tight fist; his left (not visible here) grasps a sword. He is the embodiment of composed and ceaseless vigilance in this photograph by Bill Wierzalis. (Courtesy of Bill Wierzalis.)

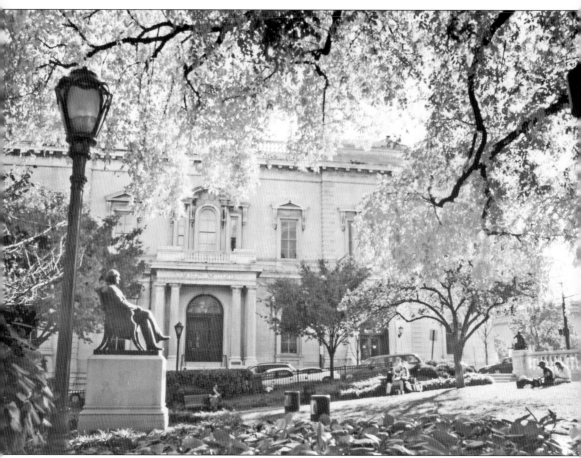

George Peabody looks quite comfortable and pleased, as though he were relaxing in his parlor, in this statue—a copy of the original in London—by American sculptor William Wetmore Story (1819–1895). In 1850, Story moved to Rome, where he spent his remaining years. He cultivated a number of important friendships there, notably with Nathaniel Hawthorne, who famously described his sculpture *Cleopatra* in *The Marble Faun*, and Henry James, who reluctantly wrote his biography. In a sonnet, Story, a poet as well as sculptor, describes a day much like this one: "After long days of dull perpetual rain, / And from gray skies, the sun at last shines bright, / And all the sparkling trees are glad with light." (Courtesy of Bill Wierzalis.)

Four

A Cultural Space

It takes but a moment's consideration to see that the cultural institutions, venerable and durable as they are, differ in mood, in atmosphere, and in their affiliation to the area. Two stand out.

The Enoch Pratt Free Library dwells like a benign, avuncular force on Cathedral Street. It opens its arms to any and all. Enoch Pratt conceived his library, as he explained to his minister, Rev. Charles R. Weld of the First Independent Christ Church (Unitarian), "as a free circulating public library, open to all citizens regardless of property or color." His first building, erected in 1886, seems, from our vantage today, to have been an amusingly eccentric pile. But the structure that arose to replace it in 1933 exudes a noble strength and stands as a realized ideal. The main room resembles nothing so much as the lobby of a splendid railroad station. It is capacious but not intimidating, at once utilitarian and humane. It knows why it exists. This is a grand and welcoming space.

A different amity distinguishes the Delano and Aldrich design for the Walters Art Gallery, built in 1904. Today it may at first seem stranded and awkward, like a guest who has arrived at the wrong party. But the design shows great sensitivity to the south park facing it, especially so at the time it was built, before the landscape of the Olmsted firm was effaced and the eloquent monument to Severn Teackle Wallis—an intimate friend of Henry Walters—was exiled to the east park and an unearned obscurity.

The original entrance faced the park. Despite the dutiful facade, nothing could have prepared the visitor for what awaited beyond the threshold. Here is a space that educates as it edifies the eye. Despite occasional lapses—Delano came to regret the steep pitch of the staircase—it is among the finest expressions of the humanist ethos to be found anywhere in Baltimore. It is as much an ethical as an artistic space, and it ennobles as it gives delight. Like a practiced diplomat, it somehow manages neither to condescend nor to cater.

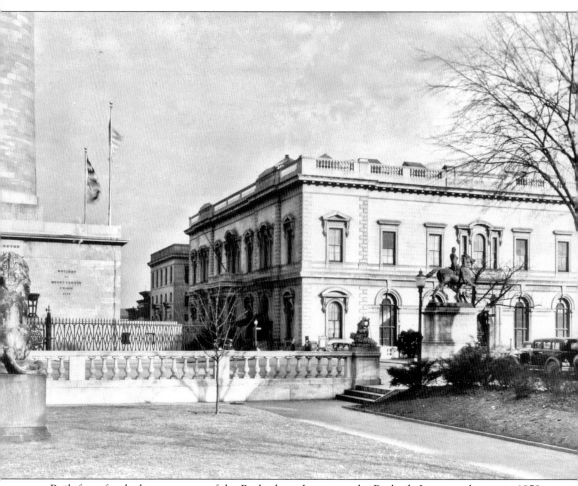

Built from funds that were part of the Peabody endowment, the Peabody Institute, begun in 1859, was not completed until 1866 because of delays caused by the Civil War. Edmund G. Lind, an English architect who arrived in 1855 and settled in Baltimore, designed it. The trustees sought a design that harmonized with the neoclassical style of the monument and residences in the area. Lind provided a design in the "Grecian-Italian" style in 1858. A local Baltimore architect, James Crawford Neilson, assisted in the details of the building's construction. The result is a suitably imposing presence on the southeast corner of Mount Vernon Place. (Courtesy of the Enoch Pratt Free Library.)

This portrait depicts George Peabody (1795–1869) dressed in the style of an English gentleman. Born in Danvers (renamed Peabody), Massachusetts, to a family of modest means, Peabody received little formal education. Volunteering for service in the War of 1812, he met Elisha Riggs of Baltimore. In 1814, they established a wholesale dry goods business, Riggs, Peabody, and Company. By 1837, having made the bulk of his fortune, he relocated to London, where he first began his philanthropic pursuits. In this area, his principal interests were the improvement of society and providing the less fortunate with the means to advance themselves. In 1857, he gave funds to establish the Peabody Institute in Baltimore, the city where he had made his fortune. (Courtesy of the Enoch Pratt Free Library.)

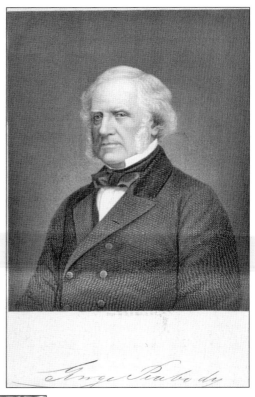

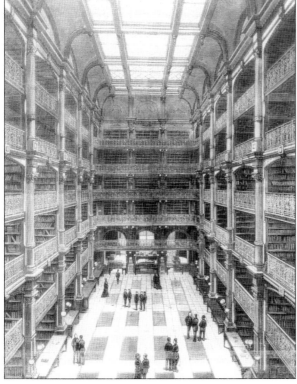

When the trustees commissioned Edmund G. Lind to design a library to complement his design of the Peabody Institute (1859–1866), they wanted a space that was economical and fireproof. What they got in addition was one of the most impressive interiors constructed of cast iron in America. Completed between 1876 and 1878, it is executed in the neo-Grec style, in keeping with the dominant architectural sensibility of Mount Vernon Place. As Phoebe B. Stanton has noted, the library and the institute "give scale to the present and tell of the intellectual attainment, the building skills and the precision of tastes of a century ago." (Courtesy of the Enoch Pratt Free Library.)

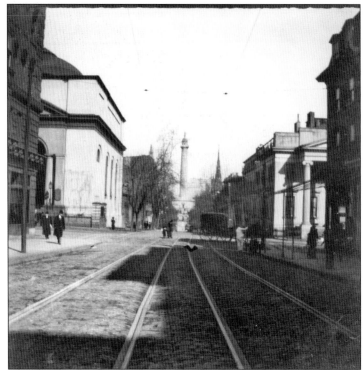

This photograph, which Fowler took slightly below Franklin Street looking north on North Charles Street, shows how the new nation's classical affinities imposed a sense of order to the area. Godefroy's First Unitarian Church on the left and the Athenaeum Club on the right bring symmetry, balance, and formal dignity to the scene. They stand like heralds before Mount Vernon Place, which rises behind them. (Courtesy of the Enoch Pratt Free Library.)

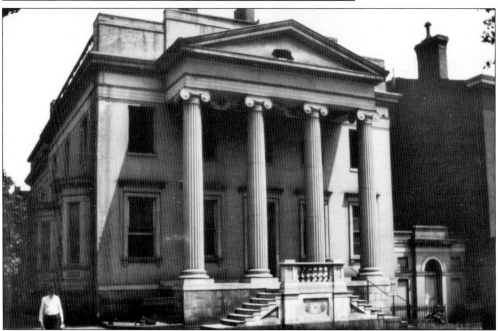

This is a view of the Athenaeum Club, which stood on the northwest corner of Franklin and Charles Streets. Letitia Stockett recalls that it was a warm, pale yellow. Originally a private home, it exhibits a character unlike the houses on Mount Vernon Place in that it was a freestanding house with a private garden. With its four Ionic columns, it aspires to a grandeur more pronounced than the residences farther north. It was razed around 1910. (Courtesy of the Enoch Pratt Free Library.)

The block has a
pleasant stateliness
in this view of East
Franklin Street near
the intersection with
North Charles Street.
The Athenaeum Club
is the nearest building
in the photograph. The
First Unitarian Church
and the YMCA anchor
the street beyond. This
photograph was taken
by Laurence H. Fowler
sometime around 1910.
(Courtesy of the Enoch
Pratt Free Library.)

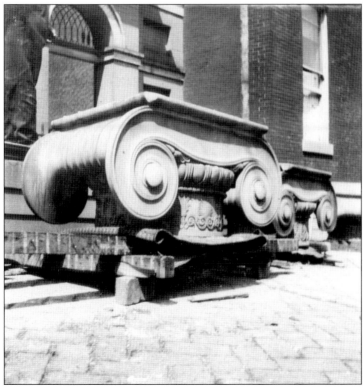

Laurence H. Fowler
took this photograph
of one of the Ionic
capitals of the
Athenaeum Club as
the building was being
razed around 1910.
The building,
originally known as
the Howard residence,
was built in 1829.
The entire portico—
including this
piece—was salvaged.
(Courtesy of the Enoch
Pratt Free Library.)

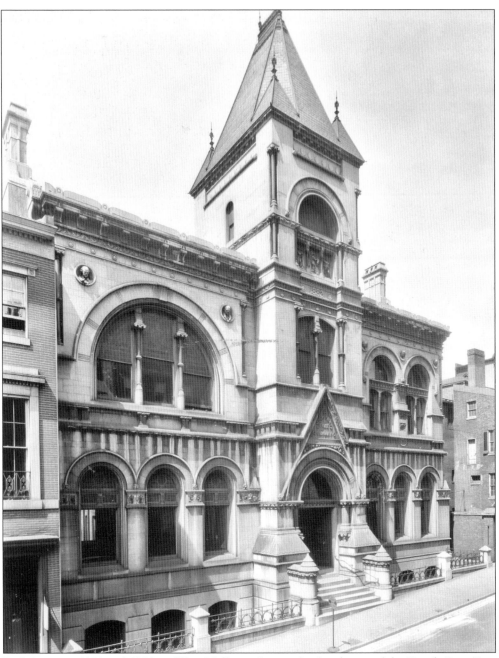

Built between 1881 and 1886 on West Mulberry Street, the first home of the Enoch Pratt Free Library announces its public and civic purpose in its choice of the courthouse Romanesque style. The architect was Charles L. Carson (1847–1891). The Romanesque tower seems grand enough, but it lacks a desirable grace. His handling of the street level, however, seems very appealing. (Courtesy of the Enoch Pratt Free Library.)

This photograph of the imposing interior conveys in a vivid way the quality of the materials employed in the construction of the lobby of the Enoch Pratt Free Library's second main building. The beauty of the iron screen is especially notable here. The space manages to present to the patron an exalted understanding of the riches available to everyone here. (Courtesy of the Enoch Pratt Free Library.)

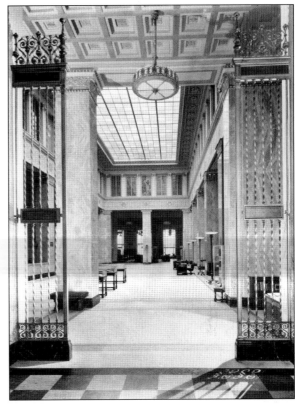

Baltimore's Eighth Annual
BOOK and AUTHOR LUNCHEON

Baltimore readers, however absorbed they may be in the task at hand, never forget their manners. A gentleman remains a gentleman, even if he has the inclinations of a scholar. This would appear to be the message of this quietly amusing piece by cartoonist John Stees. An interesting ambiguity is suggested by the preoccupied presence of both George Washington and the lady, leading one to wonder if the gentleman is exhibiting respect or courtesy. The most economical explanation is that he is demonstrating both. John Stees was a popular cartoonist for the *Baltimore Sun* for 40 years. Philip S. Haisler, former managing editor of *the Evening Sun*, once compared him favorably to James Thurber: "He just used a plain damn line, no shading or cross hatching or color. He could tell a story." The Book and Author Luncheon continues today as the Booklovers' Breakfast. (Courtesy of the Enoch Pratt Free Library.)

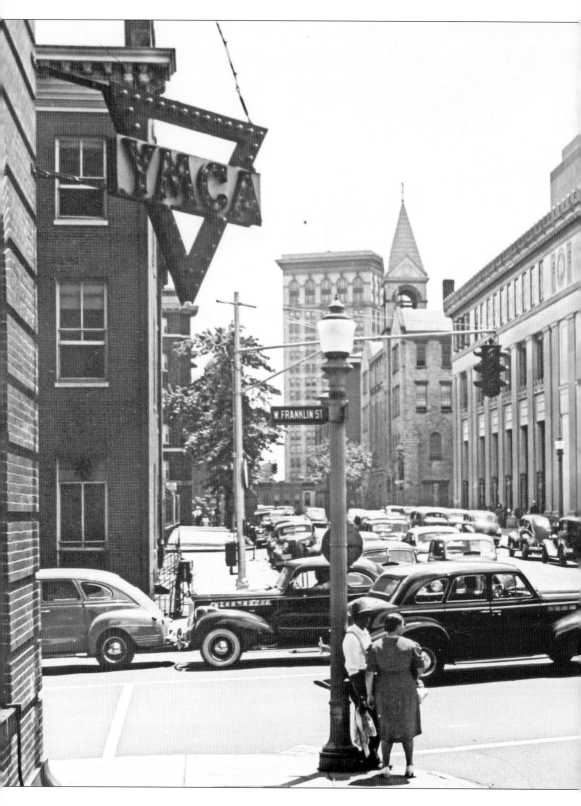

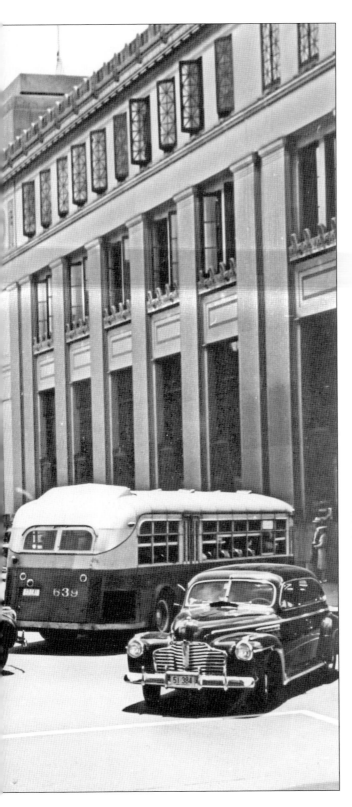

A couple in the foreground pauses by a lamppost at the northeast corner of West Franklin and Cathedral Streets, seemingly marooned as the traffic teems around them on a hot summer day before mid-century. The YMCA building, on the left, wears its distinctive logo like a medal. The new Enoch Pratt Free Library building, with its dramatic vertical lines, is a fresh and dramatic presence on the site. Behind it, Calvert Hall stands like a fortress. The Baltimore Gas and Electric Company building rises majestically in the distance. (Courtesy of the Enoch Pratt Free Library.)

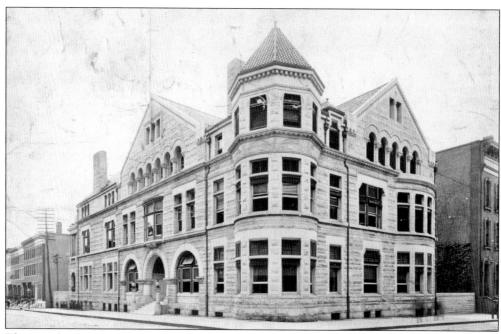

The Maryland Club was founded in 1857, in the words of George W. Howard, by "a number of the most cultivated gentlemen in the State for the purpose of keeping alive a civilization in some respects peculiar, and which was endangered by the rude and vigorous strides of Young America." This photograph depicts its current building, designed by Baldwin and Pennington, shortly after its completion in 1891. (Courtesy of the Enoch Pratt Free Library.)

In Baltimore, the eye finds pleasure in the least likely places, as this photograph of a wrought-iron lamp at the Maryland Club so engagingly reveals. You feel that the craftsmen had to restrain their extravagant skills to complete this. The work speaks not only of mastery, nor merely of professional pride. Most tellingly, it speaks of a deeply rooted delight in the shape of things. (Courtesy of Bill Wierzalis.)

The west corner of Washington Place South and Centre Street, as it appeared in 1935, is a site of contrasting styles and textures. The Centre Street level is open for business, although it is hardly booming at this moment during the Depression. A solitary vehicle is parked forlornly on Washington Place South, a street that is here remarkable for its singular lack of activity. Indeed, this scene has a disturbing air of desertion. (Courtesy of the Enoch Pratt Free Library.)

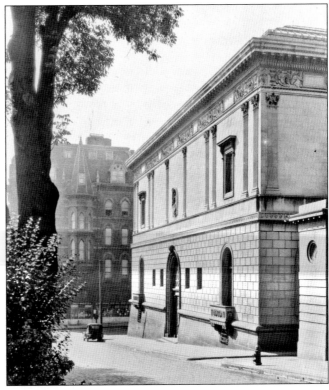

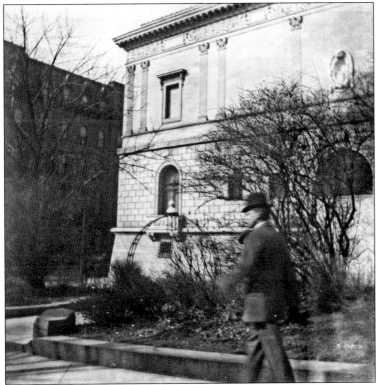

This photograph by Laurence H. Fowler gives an unusual and unrepeatable view of the Walters Art Gallery partially framed by the foliage and decoration of the Olmsted plan of the south park. An interesting feature here is the niche sans bust over the entrance. The details of the facade of the St. James Hotel on Centre Street are barely visible. (Courtesy of the Enoch Pratt Free Library.)

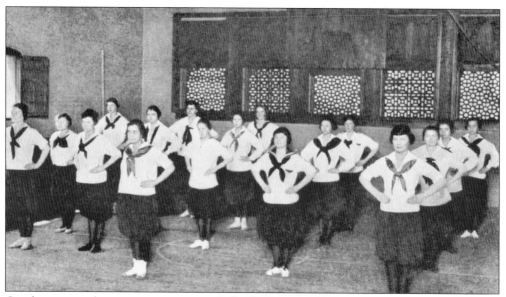

Good posture and poise were marks of good breeding—at least for women. Writing in 1902, John F. Goucher (1845–1922) claimed, "It has been said that a Woman's College student may be easily known on the streets of Baltimore by her erect pose, firm yet graceful step, and perfect, while not overstrained, decorum. For the physical features of this deserved praise, the training of the gymnasium should have credit." This photograph from around 1920 shows a gymnasium class at the Girls' Latin School, originally located on the grounds of the Woman's (later Goucher) College. In 1914, it leased the Winans House on St. Paul Street. The gymnasium occupied what had been the stable. (Courtesy of the Enoch Pratt Free Library.)

Between 1914 and 1928, the Girls' Latin School leased the Winans House. Designed by Stanford White (1853–1906) in the François I style, it was completed in 1882. Conceived and built on a grand scale, the house, as this photograph so endearingly suggests, served its educational mission well with its spacious and well-proportioned rooms. (Courtesy of the Enoch Pratt Free Library.)

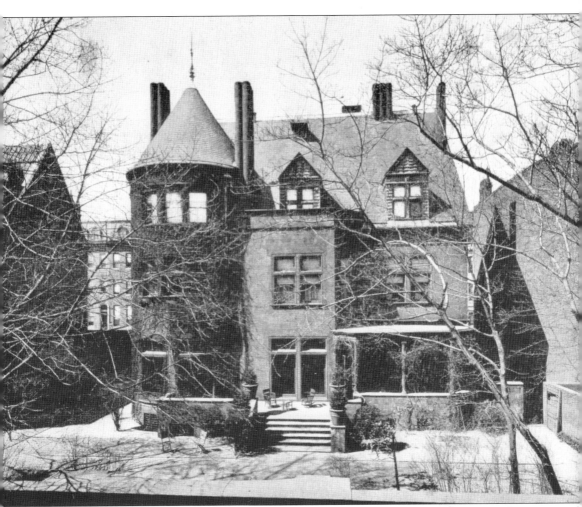

The Girls' Latin School was organized in 1890 in order to provide suitable preparation for college-bound young women. In describing the school, founder John F. Goucher noted, "It early became evident that, owing to the inadequate courses of the secondary schools of Baltimore and of much of the territory from which the institution [i.e., Goucher College] was drawing its students, the college must supervise its preparatory work." Goucher, perhaps too rosily, foresaw a time when the quality of public secondary education would so improve as to make the school's mission redundant. The enrollment was never very large. Around this time, it stood at 183, with roughly 80 percent of the students hailing from Baltimore. (Courtesy of the Enoch Pratt Free Library.)

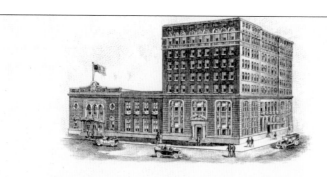

KNIGHTS OF COLUMBUS CLUB
BALTIMORE, MARYLAND

Baltimore's association with the Knights of Columbus has deep roots. James Cardinal Gibbons ordained its founder, Michael J. McGivney, at the Cathedral of the Assumption in 1877. By the 1920s, the organization had outgrown its facility at 109 West Mulberry Street and purchased the town house of Alexander Brown on the northwest corner of Cathedral and West Madison Streets in 1921. The cornerstone was laid on October 12, 1924. In 1942, it was converted for use as an air-raid shelter. For a number of years, it was the social center for Catholic men. Later it became the Hotel Alcazar, taking its name from the summer castle of Ferdinand and Isabella, where they met with Columbus. By the 1970s, it was only marginally profitable. The City of Baltimore bought it to convert to a school for the arts. At the auction of the facility's chattel in 1978, one oil portrait of Cardinal Gibbons sold for $150. Another went for only $90. (Courtesy of the Enoch Pratt Free Library.)

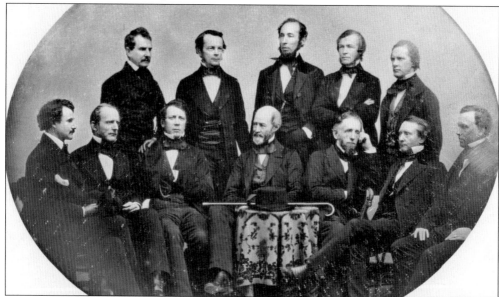

Severn Teackle Wallis, seated second from the left, joins other members of the Friday Club for their group portrait, taken before 1859. Begun in 1852, the club met every other week at each other's houses from 8:00 to 12:00 p.m. for supper and conversation. Politics were not discussed. The last meeting was held on March 22, 1861, before the outbreak of the Civil War, which put an end to the club. Along with Henry Winter Davis (seated far left), Wallis, according to one account, "always dressed very well, as was the custom with lawyers when they went into court in those days." (Courtesy of the Enoch Pratt Free Library.)

This building, originally a stable, must have seemed destined for greater things, and it would seem to have found its métier as a woman's club in this 1940 photograph. Before that, though, it had been a garage and a studio. Clearly the women using the club had uncommonly good taste. (Courtesy of the Enoch Pratt Free Library.)

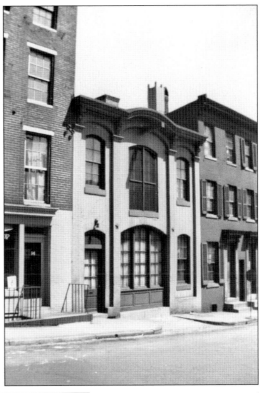

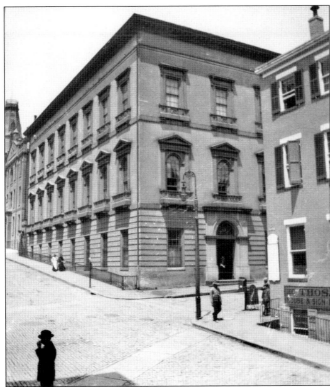

The figure at lower right seems to have wandered in from a painting by René Magritte in this photograph by Laurence H. Fowler from the early 20th century. It shows the Baltimore University Law Department. In the foreground is the Thomas Guilliam Sign Painters Company at 100 East Saratoga Street. Behind it is Public School 100. The cupola of the Wilson Building is visible at the top of the frame. (Courtesy of the Enoch Pratt Free Library.)

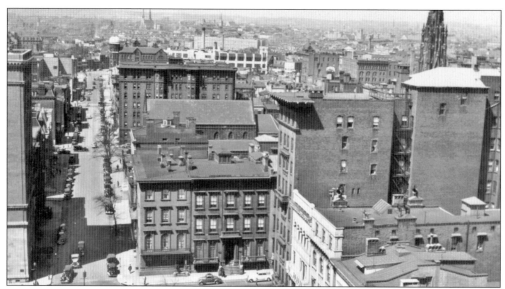

Taken from the Washington Monument, this view down West Monument Street shows the area as it appeared in 1936. In the far distance, the domed tower of a science laboratory of the Johns Hopkins University rises beyond Howard Street. The Winona Apartments and Grace and St. Peter's Parish face each other on Park Avenue. The Severn Apartments building casts an indifferent rear facade upon the houses lining the north end of West Mount Vernon Place. (Courtesy of the Enoch Pratt Free Library.)

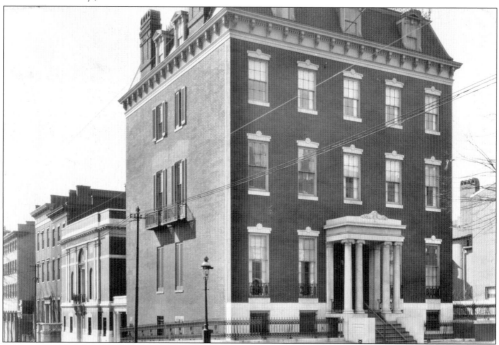

The Enoch Pratt house, as it appeared sometime after 1919, sits on the southwest corner of West Monument Street and Park Avenue. Built in 1847, it was the residence of Enoch Pratt (1808–1896), who made his fortune as a hardware merchant. It became the site of the Maryland Historical Society in 1905. (Courtesy of the Enoch Pratt Free Library.)

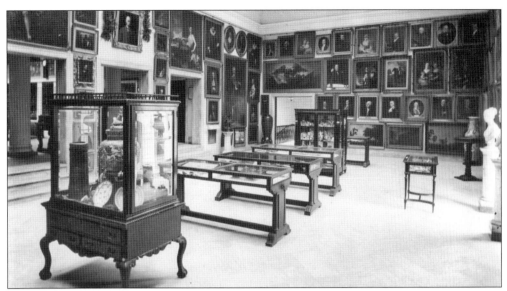

When does a people decide it has a history? In 1844, "a number of gentlemen" decided that the time had arrived, and they formed the Maryland Historical Society in order "to collect the scattered materials of the early history of our State, and to preserve the memorials of the eventful periods through which it has passed." It held its first gallery exhibition in 1848, and in the same year, it also set itself up in the Athenaeum building, which it shared with the Baltimore Library Company and the Mercantile Library Association. In 1919, it moved to the area it currently occupies. This photograph shows the collection on display in the fulsome style of the period. (Courtesy of the Enoch Pratt Free Library.)

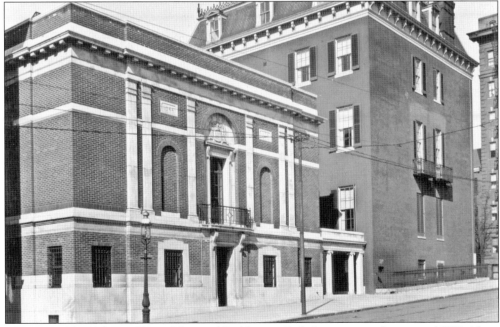

This view of the H. Irvine Keyser Memorial Building on Park Avenue was taken around 1927. Along with the Enoch Pratt house contiguous to it, it comprised the facilities of the Maryland Historical Society before its major expansion in the 1980s. (Courtesy of the Enoch Pratt Free Library.)

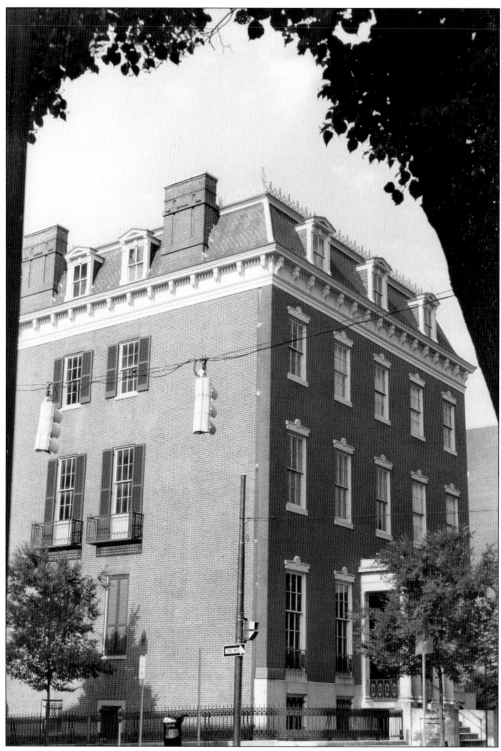

Now part of the Maryland Historical Society, the Enoch Pratt House has been partially restored and refurnished to reflect the style and customs of the 19th century. (Courtesy of Bill Wierzalis.)

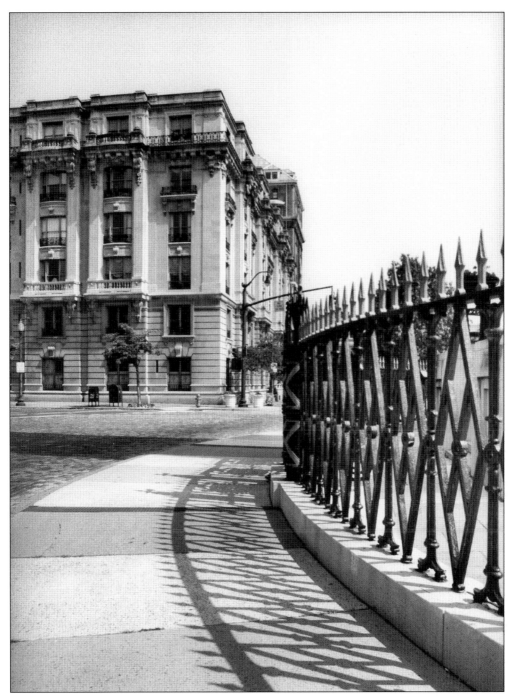

In the design of the fence surrounding the monument, Robert Mills clearly aimed at intensity. This is not a simple ornamentation; rather, it is a strong, iconic statement about the perils and duties facing the citizens of a young republic. It emphasizes that the father of our nation was also a warrior who ultimately prevailed through virtue as much as through tactical skill. Cincinnatus yields power when his task is accomplished. But he will not beat every sword into a plowshare. (Courtesy of Bill Wierzalis.)

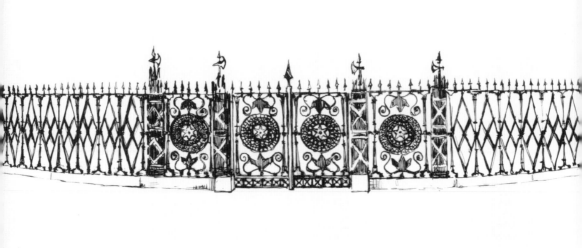

This lovely pen-and-ink sketch of a portion of Robert Mills's cast-iron fence on the perimeter of the Washington Monument depicts his design in understated detail. As Robert L. Alexander has noted, "symbolism resides in the iron work." The spearheads on the railing and the axes represent readiness and resolve, the fasces, the strength of union. The gate panels are encircled by 12 stars, representing the states, with a six-pointed star referring, in all likelihood, to the state of Maryland, where the monument resided. (Courtesy of Silvia Agachinsky.)

Five

A Domestic Space

John Dorsey devotes a portion of his graceful *Mount Vernon Place: An Anecdotal Essay* to chronicling the lives and adventures of some of the personages who lived here at the turn of the century. At times it reads like Noel Coward; at others like Philip Barry. These episodes are the mores and antics of another era. It is probably safe to say that it is unlikely to recur. One is tempted to observe that what remain are vestiges. The vitality of daily life—with its eccentricities, prejudices, aspirations, and disappointments—has surely dissipated here by now.

And yet the conversations have not altogether died. The houses themselves perpetuate them. The most interesting quality of these buildings is not how well they reflect one style or the other, not this unusual detail or that remarkable material. It is that they all, as if by common agreement, eschew ostentation. They are hardly severe in appearance, to be sure, but they are nowhere near grandiose. They display a restraint that passes as a kind of architectural courtesy. It would be a mistake to call it deference. Yet it does show that they not only know how to speak but also how to listen.

Such houses are astonishingly attentive. They listen not only to each other but also to much of the world besides. With its superlative harbor, Baltimore developed a cosmopolitan culture whose effects are felt throughout Mount Vernon Place. More than one observer has noted the engaging texture of the place. With greater exuberance and richer detail, Henry James stated what others before and since have responded to—the domestic scale of Mount Vernon Place. As he ponderously observed, it feels like someone's drawing room. This, one can argue, is not solely the function of taste, nor of sensibility. In the lines and proportions of these houses, one is presented with a simple ethic. They possess many extravagances. But you must cross a threshold and enter to see them. The instincts of privilege are gentle in Baltimore. The public face is that of a democratic and cordial restraint.

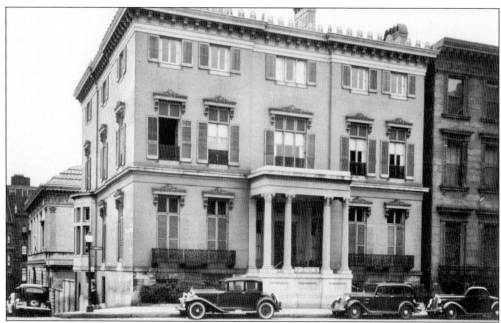

Built in 1849 from a Niernsee and Neilson design, the Thomas-Jencks-Gladding House is, in the words of John Dorsey, "one of the great houses of Mount Vernon Place and indeed one of the great town houses of the Nineteenth Century." It is shown in one incarnation with a painted facade and dowdy shutters. Its style—Greek Revival with Italianate ornamentation—represents a development of the neoclassical design then prominent in Baltimore. (Courtesy of the Enoch Pratt Free Library.)

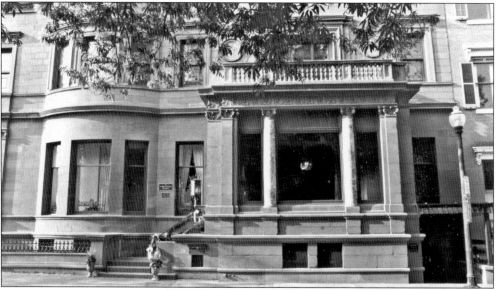

Lights of a chandelier flicker like votive candles in the dark, deep space beyond the entrance to the Garrett-Jacobs Mansion at 7–11 West Mount Vernon Place. They seem to emit a kind of yearning, or perhaps a welcoming. Despite its grandeur, this is, indeed, an interesting example of the inherent sociability of houses. The architects seem to have crafted a socially vibrant space. This is where the most lavish and most exclusive social events were held for a generation in Baltimore. Today the Engineering Society of Baltimore continues the genial traditions. (Courtesy of Bill Wierzalis.)

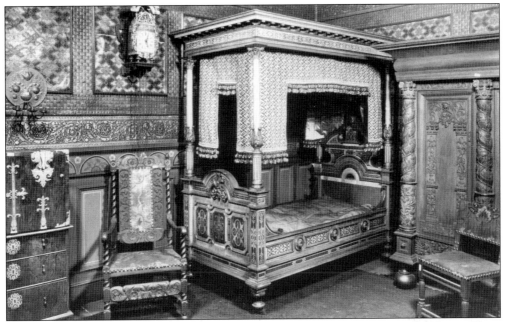

This is a view of the Dutch bedroom in Henry Walters's residence at 5 West Mount Vernon Place. According to William R. Johnston, it was located off the landing between the second and third floors. Looking at it today, one wonders how anyone ever managed to relax, not to mention find repose, in it. It seems likely to induce either over-stimulation or claustrophobia. (Courtesy of the Enoch Pratt Free Library.)

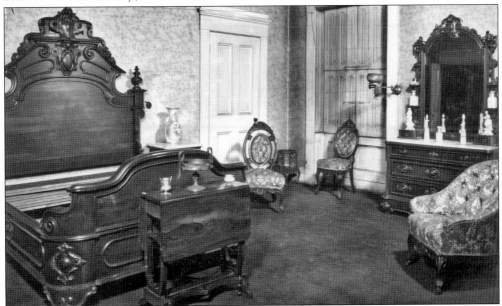

This view of another bedroom in the Walters residence seems more inviting. Walters stocked his house with imported and locally manufactured furnishings. For local items, he relied on Henry W. Jenkins and Sons, a business that had operated in Baltimore since 1798 as both a cabinetmaker and an undertaker. It ceased its cabinetmaking business in 1904. Many of the pieces in the Walters residence were made expressly for him. (Courtesy of the Enoch Pratt Free Library.)

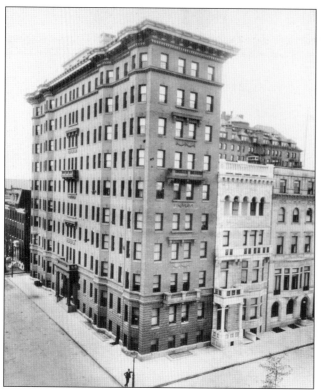

A man leans nonchalantly against a lamppost like a scene from "The Drunkard" in this photograph from 1937. But the real drama is taking place behind him, where the Severn Apartments, designed by Charles E. Cassell (c. 1842–1916), dominates the corner. The photograph is remarkable because there is not an automobile in sight. (Courtesy of the Enoch Pratt Free Library.)

The house at 107 West Monument Street appears to be posing for a portrait in this undated photograph taken for the Hughes Company, a commercial photography studio that operated for many years in Baltimore. Built sometime before 1837, the building was converted to a three-family apartment building in 1936. (Courtesy of the Enoch Pratt Free Library.)

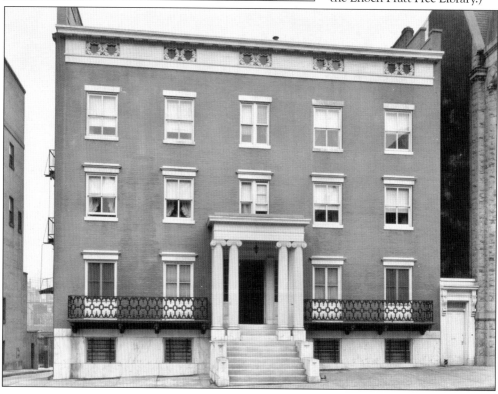

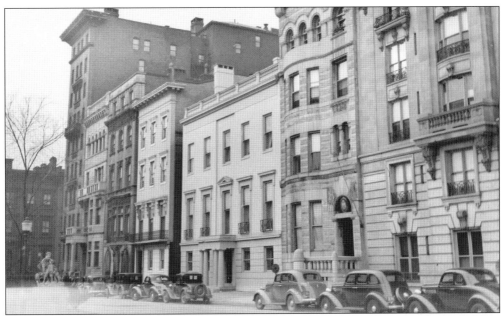

The north side of West Mount Vernon Place, in a photograph taken in 1936, looks vaguely like a concertina with the out-of-scale Washington Apartments and Severn Apartments dominating the corner. The south facade of the Washington Apartments is on the far right. To its left is 6 West Mount Vernon Place, which at this time was the location of the Italian Consulate. (Courtesy of the Enoch Pratt Free Library.)

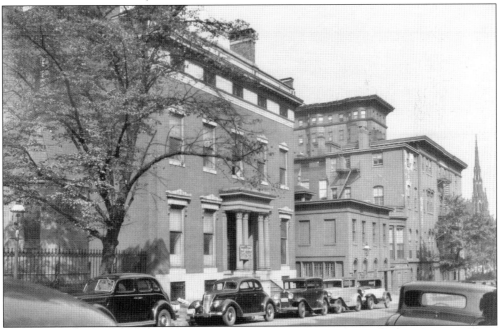

This handsome residence at 104 West Monument Street was adjacent to Grace and St. Peter's Parish, whose cast-iron fence juts into the lower-left frame. The Severn Apartments and the spire of Mount Vernon Place Methodist Episcopal Church rise in the background. Mary Washington Keyes resided here when she died in 1931. (Courtesy of the Enoch Pratt Free Library.)

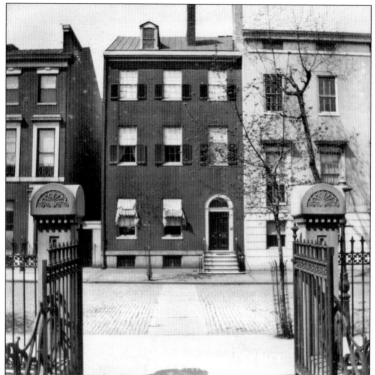

This view taken by Laurence H. Fowler is of the 400 block of Cathedral Street from the cathedral gate in the early 20th century. It shows three of the houses that stood on the site of the current location of the Enoch Pratt Free Library. (Courtesy of the Enoch Pratt Free Library.)

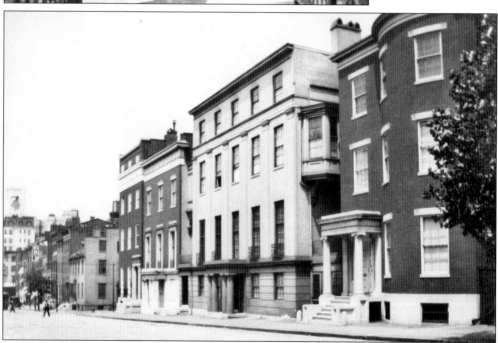

In this photograph of the 100 block of West Franklin Street looking west, Laurence H. Fowler portrays a queue of residences that seem forlorn and withdrawn. The Tiffany House is at right, the Frick at left. Every shade save one is pulled against the street. What little activity there is appears to take place in the blocks beyond, farther west. (Courtesy of the Enoch Pratt Free Library.)

The blind arches on this impressive stable suggest the influence of Benjamin Latrobe or Robert Mills. Facilities for horses not only had to be adequate for the animals' needs but also, depending on one's social status, had to make a statement. In this photograph by Laurence H. Fowler, however, the statement appears to be unheeded by the two women in black who, like figures in a work by Edvard Munch, pass briskly and solemnly past each other. A man, wearing what appears to be a top hat, stands vacantly at the photograph's right edge. (Courtesy of the Enoch Pratt Free Library.)

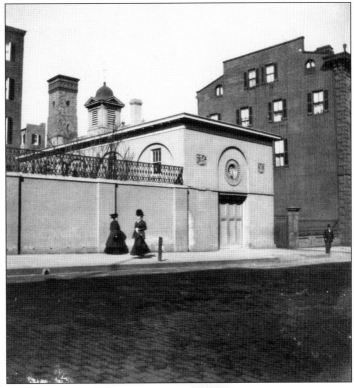

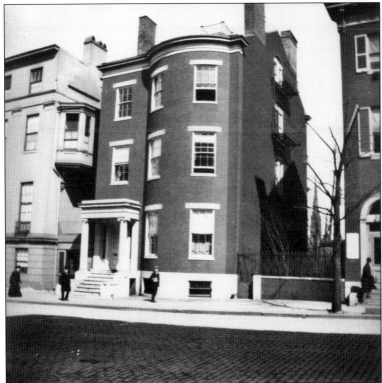

Like stragglers at the conclusion of a long march, four people walk eastward in this Laurence H. Fowler photograph of the Tiffany House at 118 West Franklin Street, taken around 1910. The spire of First Presbyterian Church can be seen in the gap between houses to the right. (Courtesy of the Enoch Pratt Free Library.)

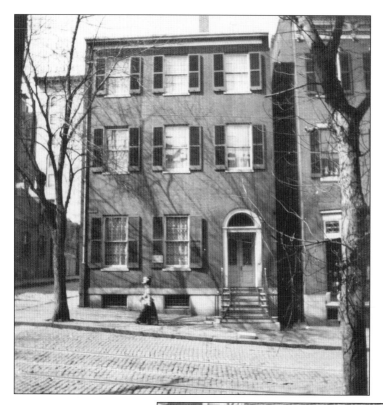

A woman in fancy attire walks vigorously up the slope of Charles Street at Hamilton Street in this photograph by Laurence H. Fowler taken around 1910. Behind her is the Turnbull House at 516 North Charles Street. The YMCA building is visible in the distance. (Courtesy of the Enoch Pratt Free Library.)

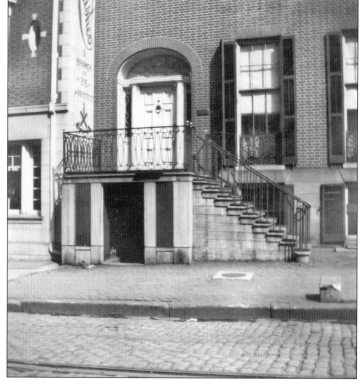

At the time Lawrence H. Fowler took this photograph (around 1910), this building housed the Girls' Friendly Society. It was formerly the James Sloan House and at one time had a garden where 419 and 421 North Charles Street now stand. (Courtesy of the Enoch Pratt Free Library.)

Laurence H. Fowler took this photograph of 415 North Charles Street, the Cohen House, in the early 20th century. The scrawny tree at right seems incapable of casting much shade, and it doubtless would have made a sad ornamental. But the shadow on the facade has come from somewhere, and this shabbily leafed tree seems the likeliest source. (Courtesy of the Enoch Pratt Free Library.)

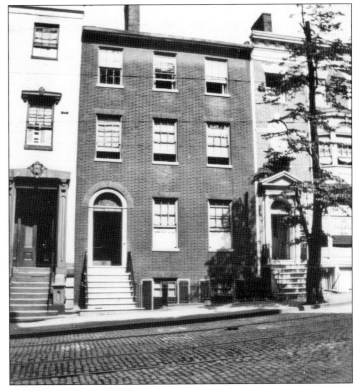

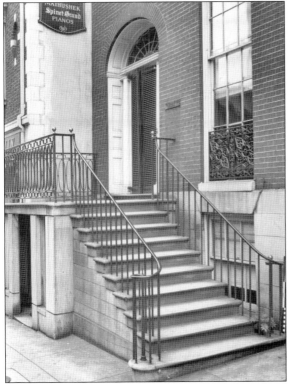

Iron and marble are gracefully employed in this charming entrance to 419 North Charles Street, the home of the Girls' Friendly Society. Founded in 1878, it sought "to provide the social, educational, physical and spiritual betterment of girls"—a tall order, but one in which it was evidently successful, celebrating its 75th anniversary in 1953. It welcomed girls "of any or no church," but workers were required to be communicants of the Episcopal Church. (Courtesy of the Enoch Pratt Free Library.)

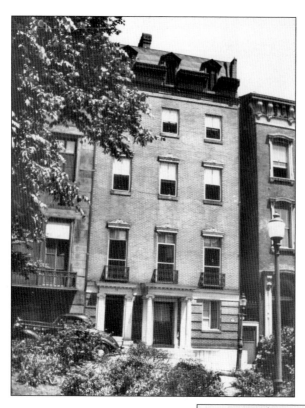

This is a view of 14 East Mount Vernon Place in June 1939. The etiology of this building is somewhat confusing. John Dorsey reports that it was originally owned by Col. Charles Carroll; it was known as Miss McConky's boardinghouse in the late 1870s. Information accompanying this photograph, however, says that it was where Mrs. Mary Jones conducted a school for girls known as Mount Vernon Institute before 1861. (Courtesy of the Enoch Pratt Free Library.)

Discussing the influence of Benjamin H. Latrobe's classicism on Baltimore's architectural tastes and development, Letitia Stockett chose this facade, at the northeast corner of Cathedral and West Madison Streets, to support her argument. It is, indeed, a lovely, tasteful example of impressive simplicity and scale. At the time this photograph was taken, it was the residence of Rev. Tagart S. Steele Jr., the rector of St. David's Episcopal Church in Roland Park from 1927 to 1936. Today it has undergone various minor alterations, the cumulative effects of which, however, mar rather than burnish its appearance. (Courtesy of the Enoch Pratt Free Library.)

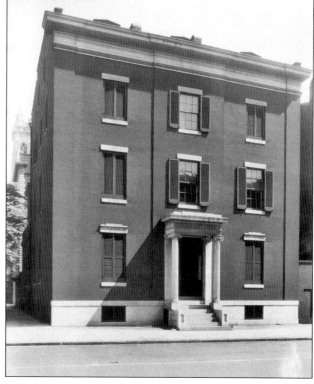

A view from 1936 of the 100 block of Hamilton Street looks west. This block has frequently been compared to London, a comparison it doesn't really need. It can stand on its own. It is an echo of Mount Vernon Place—not so grand, nor sophisticated, nor fashionable, but retaining the poise and grace of its neighbor a few blocks north. (Courtesy of the Enoch Pratt Free Library.)

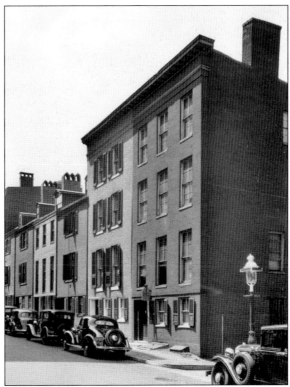

These buildings at 214–222 West Monument Street proceed like variations on a theme down the block. In this respect, they do not compete with one another. Each nicely complements the other buildings on this block, yet each also retains an individual identity that is the architectural equivalent of a personality. The hotel sign at the right edge of the frame refers to the Hotel Sherwood, a family hotel designed as winter residences for people in the suburbs. It was located at 212 West Monument Street. In 1976, it was the site of a fire that one person recalled as causing several fatalities and featuring "spectacular rescues." In 1977–1978, the Maryland Historical Society razed the building and converted the site to a parking lot. (Courtesy of the Enoch Pratt Free Library.)

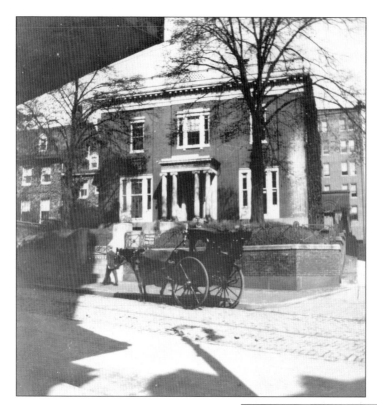

A hansom cab stands outside the Royal Arcanum building at 18 West Saratoga Street in this photograph by Laurence H. Fowler from about 1918. It was formerly the residence of Johns Hopkins (1795–1873). The St. Paul's Rectory is at left. (Courtesy of the Enoch Pratt Free Library.)

It looks like an artifact unearthed from an ancient archaeological site, but the horse trough pictured here in a photograph from 1940 was an up-to-date model, according to one newspaper account. It stood in front of the headquarters of the Maryland SPCA at 612 North Calvert Street. For those not aware of its purpose, someone had obligingly painted in bold, neat letters, "NO PARKING / FOR HORSES ONLY." In 1956, an automobile backed into it and knocked it over. It was summarily retired. It had reportedly been dry for months. (Courtesy of the Enoch Pratt Free Library.)

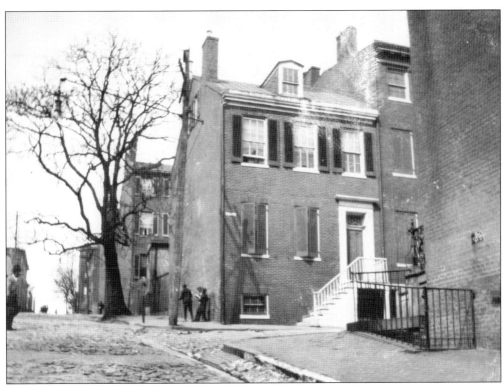

The rugged texture makes the street look ancient and well traveled in this photograph of Courtland Avenue and Mulberry Street taken by Laurence H. Fowler. It gives the area a feeling of a sleepy village rather than a bustling city. After all, who or what can effectively bustle on a road like this? (Courtesy of the Enoch Pratt Free Library.)

These crude stone blocks, chiseled at the edges by time or negligence, once performed a delicate task—to ease a lady's entrance or departure from sidewalk to carriage. At one time, mounting blocks such as these were, along with horse troughs, common features of urban life. They not only evoke an era of gentility long since passed, they also recall the essential role that the horse played in the day-to-day life of the city until the beginning of the 20th century. (Courtesy of the Enoch Pratt Free Library.)

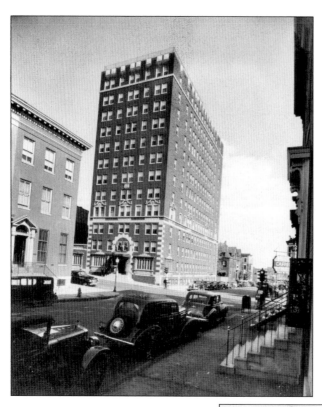

This is 1001 St. Paul Street, one of three properties in the Mount Vernon area formerly owned and operated by the Guilford Realty Company. According to its promotional literature, its properties were designed to meet "the apartment needs of the average family or individual." This building featured 102 "bachelor and light housekeeping" units. Each had an outside exposure, an important feature before air-conditioning. Apartments were available with or without maid service. The facility contained a dining room, which could seat 65. The owners were particularly pleased about the southern exposure, which afforded residents "plenty of sunshine." (Courtesy of the Enoch Pratt Free Library.)

This is a side view of Daniel Coit Gilman's residence at 614 Park Avenue, near the first campus of Johns Hopkins University. Gilman's resume reads like a how-to guide to the future. He was instrumental in shaping the course of American higher education through the 20th century. While at Yale, Gilman (1831–1908) helped to found the Sheffield Scientific School, now an integral part of Yale University, which paradigmatically pointed the way for the shift from a classically oriented education to one that included a stronger emphasis on science. He became president of Johns Hopkins in 1876 and instituted a graduate program on the German model, which became the foundation for unprecedented American success in scholarly and scientific venues. (Courtesy of the Enoch Pratt Free Library.)

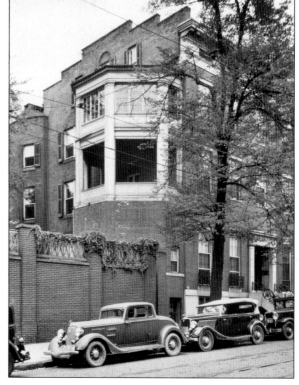

The Madison Apartment-Hotel was another Guilford Realty Company property at 817 St. Paul Street. The Madison Beauty Shop is gone. The sign pictured here overhangs a stairway that leads to the basement, which is now the site of the Audrey Herman Spotlighters Theatre, a community theater with an active and, by its own account, a "cutting-edge" production schedule. Audrey Herman (1924–1999) salvaged the flagging company when its government support was withdrawn some time in the 1960s. As Brennen Jensen noted in the *Baltimore City Paper*, "Armed with $600 in capital, she was instrumental in carving a cozy, 100-seat theater out of a frumpy storeroom beneath a Mount Vernon apartment building." (Courtesy of the Enoch Pratt Free Library.)

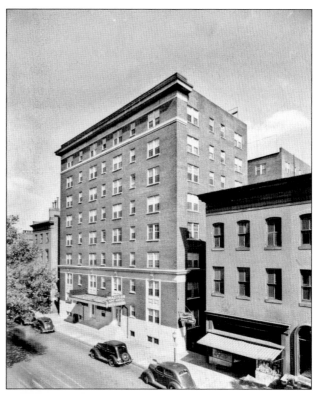

This is a view of the entrance to Gilman's residence at 614 Park Avenue. The cascading cast-iron railing must have been a common motif on Park Avenue at this time. In his inaugural speech upon the opening of Johns Hopkins University, Gilman delineated an ambitious program for American education. Success would mean "less misery among the poor, less ignorance in the schools, less bigotry in the Temple, less suffering in the hospital, less fraud in business, less folly in politics." It was a more hopeful time, perhaps. (Courtesy of the Enoch Pratt Free Library.)

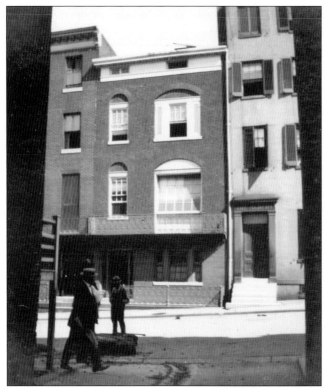

Laurence H. Fowler took this photograph of 110–112 West Mulberry Street. The Albert Apartment Building at 110 West Mulberry does not have a brick facade at the time. The property at 112 features a cast-iron balcony on the second floor and a similar railing on the first. The building is two-and-a-half stories high. The street is paved in stone, and a gutter from the alley curves into the street at front center. (Courtesy of the Enoch Pratt Free Library.)

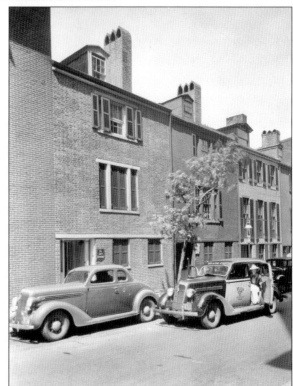

A stylishly dressed woman poses in the rear seat of a taxicab on Hamilton Street in this photograph from 1936. No. 14, third from left, housed the Hamilton Street Club. (Courtesy of the Enoch Pratt Free Library.)

Today the properties at 110–112 West Mulberry Street have been dressed with brick facades, and 112 has gained a third story. The cast-iron balcony and railings have been removed from 112. The door to 110 has obtained a glass panel. (Courtesy of Bill Wierzalis.)

The streetlight and tree are gone, but the facades remain much as they were in this present-day photograph of Hamilton Street. The new streetlight seems to have been installed with no consideration of the character of the neighborhood it illuminates. (Courtesy of Bill Wierzalis.)

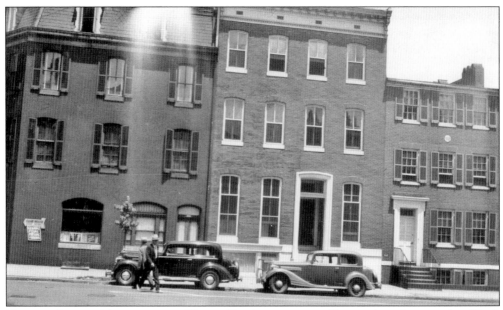

Two cars line up like props in a Warner Brothers gangster film in this photograph of Park Avenue and West Read Street taken around 1936. The men walking across the street, apparently unknown to each other, wear similar white hats. They appear ready to break into a number like Gene Kelly and Fred Astaire, with the city as one elaborate backdrop. (Courtesy of the Enoch Pratt Free Library.)

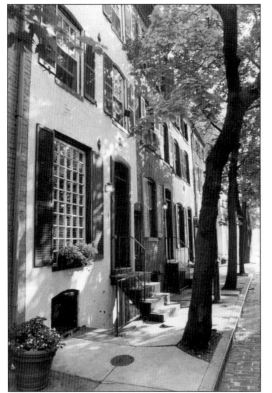

Tyson Street rose like a phoenix from its own ashes in the late 1960s, when the artist Edward Rosenfeld (1906–1983) made a home in this area, which originally housed Irish immigrant workers in the 1880s. Famed Baltimore photographer A. Aubrey Bodine observed, "Tyson Street is a standing example of how wrong the hardest of phoney city planners can be." He praised his friend Eddie Rosenfeld and his neighbors who "fought a winning battle to keep the cinder block, plaster board and tar paper gang out." (Courtesy of Bill Wierzalis.)

Six

A COMMERCIAL SPACE

Like a postmodern Gulliver, the entire city of Baltimore is entangled in restless and discontented streets. The air is loud with the urgent, relentless rush of traffic. It snarls at the city's natural serenity. So many drivers appear to chafe at the city as at an annoying impediment. For them it just gets in the way. And the streets themselves, especially those in thrall to the suburbs, slavishly agree. Not content to be simple city thoroughfares, they clamor to become highways. A few have unfortunately prevailed.

Charles Street, with its distinguished pedigree, restores a semblance of dignity and order to this cacophonous frenzy. The development of Mount Vernon brought the street to life, gave it direction, and invested it with the stature it still enjoys today. The commercial buildings constructed upon it appear to have been designed with full awareness of its favored role. And while its commercial identity has changed across generations and will doubtless change in the future, Charles Street retains many of the enticing appurtenances of traditional commerce. It proclaims continuity.

At the same time, it evinces a dutiful subordination. Its commercial buildings were intended to serve, not to dominate, the area. They were also placed with discretion. Some of the fortunes of the families residing in Mount Vernon Place were founded on trade and commerce. Judging by the placement of the stores, however, they were not eager to be reminded of it daily. Thus these buildings also resound like muted echoes of an old prosperity.

Today you must have a strong eye and a patient will to revive in the mind these crucial connections. The pace of the intersecting streets militates against it. Whenever one ventures beyond Mount Vernon Place's environs, one sees irony at full speed. Somehow, though, this place feels destined for equanimity. Perhaps, one hopes, more sensitive design will achieve what decrees cannot. Look at what happens when Charles Street divides for the south and north parks. It is as though all gratefully pause for a brief and welcome respite.

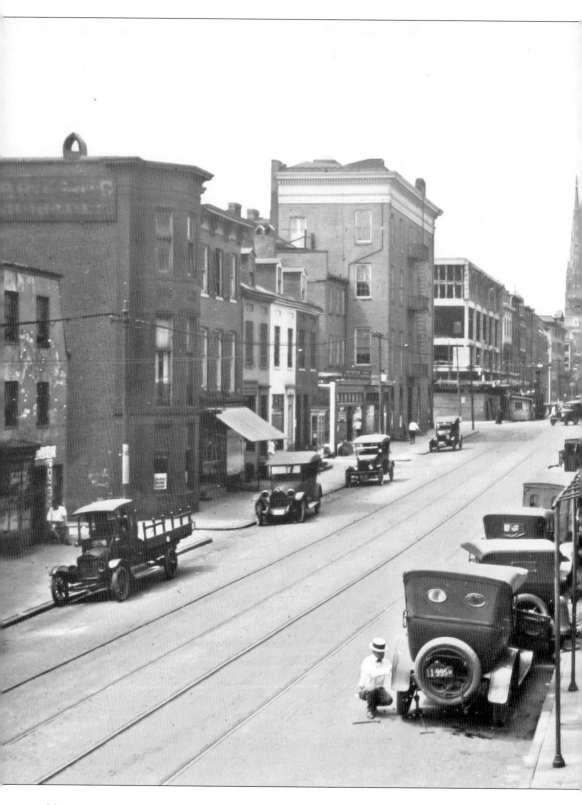

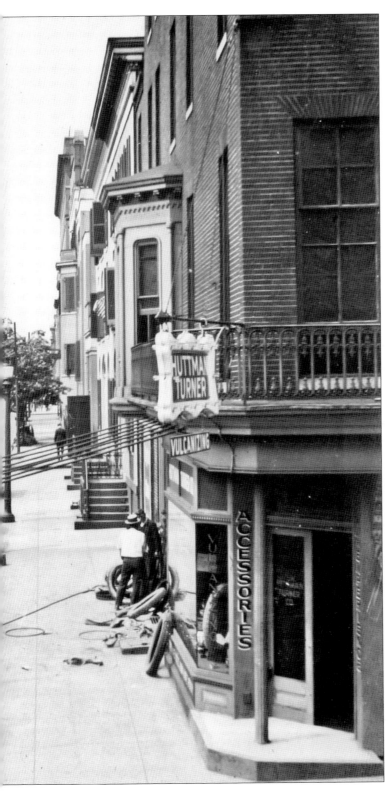

Like poets in their youth, neighborhoods begin in gladness. There is confidence in this remarkable photograph from the negative collection of Enoch Barker at the Enoch Pratt Free Library; it shows Park Avenue looking north from Mulberry Street around 1923. Business at Huttman Turner seems good. A man tidily repairs a tire in a makeshift shop on the street. Two others engage in conversation behind him. The spire of First Presbyterian Church rises in the distance. The Tar Tonic Laboratory building, pictured on page 100, rises at left. In the same row are buildings pictured on page 101. It is a hopeful, industrious scene, with the right balance between the temporal and the transcendent. (Courtesy of the Enoch Pratt Free Library.)

Here is a view of the same block of Park Avenue today. The site of this building—a remarkable, if unpretentious, survivor of another era—reads like an urban pentimento disclosing its identity through time, an identity that has become persistently and perhaps desperately international over the years. It earlier housed the Tar Tonic Laboratory of the Bertha Company. It stands on the left anchoring the block in the previous photograph. Today it is a sad and stranded vestige. (Courtesy of Bill Wierzalis.)

This photograph depicts 406 Park Avenue when it was the Tar Tonic Laboratory of the Bertha Company. It promoted the notion that disease or weakening of intellectual power could be detected by change in the hair and prevented by curing the nerves of the head. The company printed and distributed the *Blue Book* in hopes of putting it into every mother's hands. (Courtesy of the Enoch Pratt Free Library.)

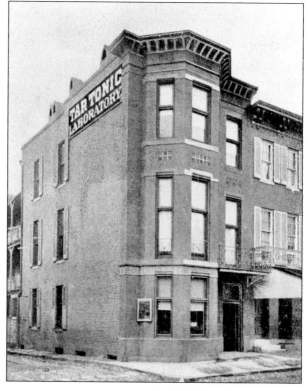

Under the West Side Memorandum of Agreement between the Maryland Historical Trust and the City of Baltimore, these buildings are designated "contributing buildings to be preserved." Looking at this photograph, it is hard to see how these two-and-a-half-story Federal-style buildings, once proud establishments on a busy, productive street, can contribute much of anything. Now they seem more like whited sepulchers. Thus to communities, as again to poets, "come whereof in the end despondency and madness." (Courtesy of Bill Wierzalis.)

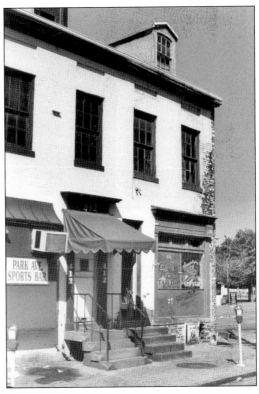

Laurence H. Fowler took this photograph of H. J. Denges, Shoe Repair, at 414 Park Avenue sometime around 1914. The cast-iron railing is not only distinctive—setting these steps apart from any others in the area—but fanciful to a degree that approaches true inspiration. They are the product of an uncommon mind and mark the proprietor as a man of rare sensibility. (Courtesy of the Enoch Pratt Free Library.)

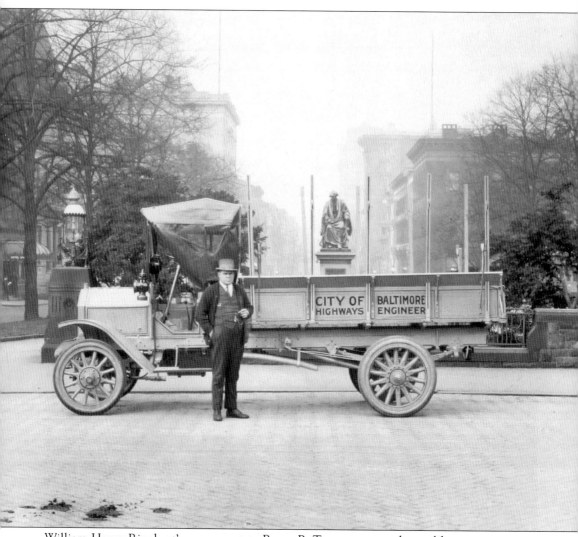

William Henry Rinehart's monument to Roger B. Taney seems to hover like a vagrant spirit from another era in this photograph of Washington Place North taken sometime before the Carrere and Hastings redesign. The man is wearing splendid attire entirely in keeping with his magnificent vehicle. Judging from the appearance of the lower left frame, he still has a bit of work to do. (Courtesy of the Enoch Pratt Free Library.)

The lamps in this photograph, taken during a snowstorm in January 2005, glow with a Dickensian aura. You would think yourself returned to the world of Victorian-era commerce. There are times when the surge of traffic—otherwise so urgent—must yield to the exigencies of the natural order. (Courtesy of Bill Wierzalis.)

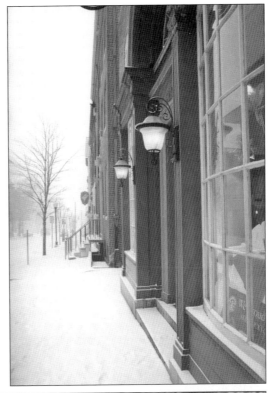

Looking at Laurence H. Fowler's nondescript photograph of a cast-iron tree shield at 1107 Cathedral Street from the early 20th century, one wonders what he knew and what he wanted us to think. Did he want us to think that Baltimore's obsession with cast-iron had risen to sublime heights or had dissolved into absurdity? Did he know he was chronicling an era about to pass? In his hands, the artless attains an inevitable fascination. (Courtesy of the Enoch Pratt Free Library.)

Men work on tearing apart the roof of the Robinson House, located on the southwest corner of North Charles and West Saratoga Streets. The photograph dates from 1905, when the house was demolished. A couple of men stare at the building. Are they curious about the commotion on the roof or transfixed by the unlikely poster of a woman engaged in an imperious pose in the far left window? Two others, including a newspaper boy, are far more interested in the photographer. (Courtesy of the Enoch Pratt Free Library.)

There is a famous photograph showing H. L. Mencken (1880–1956) merrily drinking one of the first drafts of legal beer at the end of Prohibition at 12:01 a.m. on April 7, 1933, at the Rennert Hotel. In all likelihood, he is drinking Globe Beer. The company traced its origins to 1748 and survived Prohibition by brewing near beer. Beer was for Mencken what nightingales were for Keats. It moved him to the Pierian depths of his being. It was Housman who claimed, "And malt does more than Milton can / To justify God's ways to man." But it was Mencken who adopted it as a creed. This photograph, taken before Prohibition, shows a Globe Beer facility on West Franklin Street. Its signature brand was GBS Special, whose letters are discernible here. (Courtesy of the Enoch Pratt Free Library.)

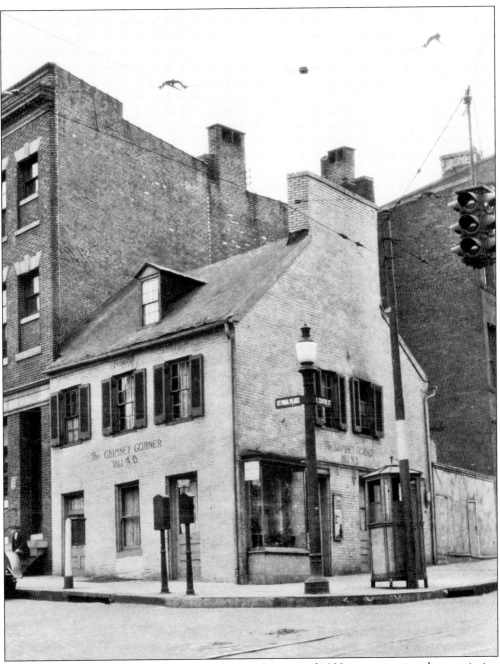

This photograph, taken by an unknown photographer around 1920, is an essay in urban semiotics. It would take an inordinate length of time to salvage all of its meanings, many of which are now obscure. Amazingly, though, the building still stands. In the 1930s, well-known cabinetmaker Enrico Liberti opened Chimney Corner Antiques here. The Chimney Corner looks like the runt of Baltimore's litter, yet it is a lesson in survival. Some buildings are prized for their beauty, others for their historical importance. Some survive because they are not deemed important enough to destroy. And a few survive simply because they're tough. The Chimney Corner looks just plain tough. (Courtesy of the Enoch Pratt Free Library.)

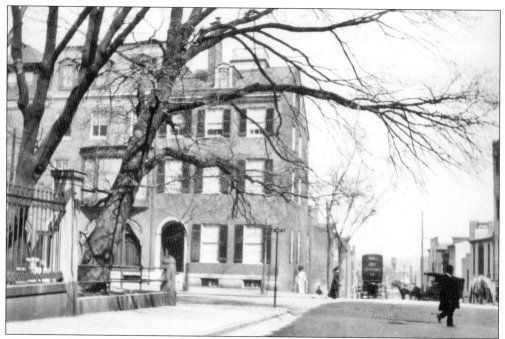

This view of Charles and Mulberry Streets looking east, taken by Laurence H. Fowler at the turn of the century, reveals Fowler's unpretentious fascination with the quotidian life of the street. Nothing is especially notable here, but looking closely at the women in the center of the frame—one wearing a white garment, the other draped in black—one gets an impression of dramatic possibilities rising to the verge of words. (Courtesy of the Enoch Pratt Free Library.)

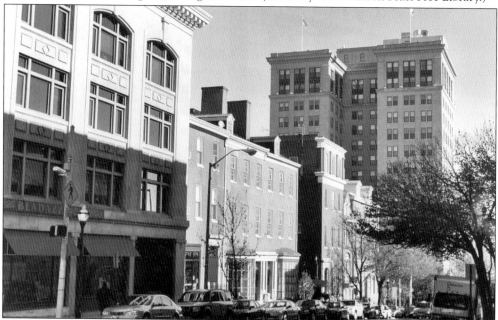

Bill Wierzalis's view of the northeast corner of Franklin and Charles Streets serves as a compendium of commercial architectural styles from mid-19th century to early 20th century. The Standard Oil Building looks approvingly at the scene. (Courtesy of Bill Wierzalis.)

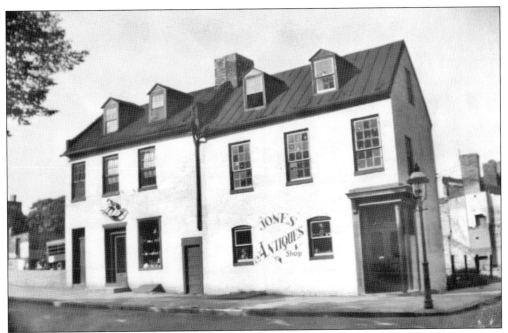

This view of a commercial building at 243 West Read Street was taken in 1940. The rocking horse over the door at left is meant to suggest a hobby shop. This vernacular structure, so radical and direct in its simplicity, looks like the setting for a poem by Crabbe or, more felicitously, Wordsworth. It has a spare Romantic aura. (Courtesy of the Enoch Pratt Free Library.)

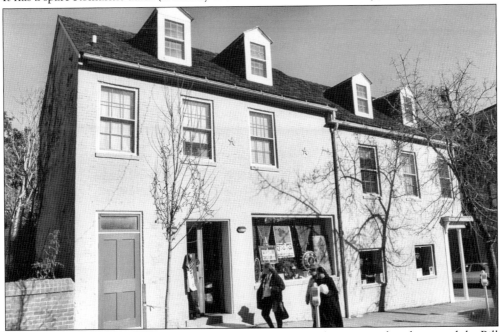

The building at 243 West Read Street looks neat and tidy in this present-day photograph by Bill Wierzalis. Time has looked upon it with favor. Today it houses Iroko, a gallery of African arts and crafts. The rocking horse is gone, but the ground-floor window opens more widely to display the array of intriguing items within. (Courtesy of Bill Wierzalis.)

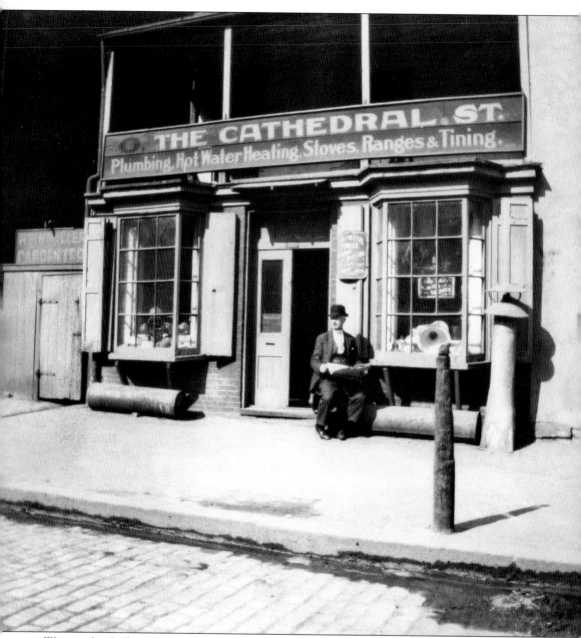

Waiting for Godot, waiting for customers, or posing for Laurence H. Fowler? John M. Knight, plumber, poses in the front of his store at 1112 Cathedral Street sometime around 1910. Here Fowler's obvious love of the vernacular and the quotidian yield to a touching pathos, making this one of his most engaging pieces. What the subject lacks in hustle, he seems to provide in fortitude. (Courtesy of the Enoch Pratt Free Library.)

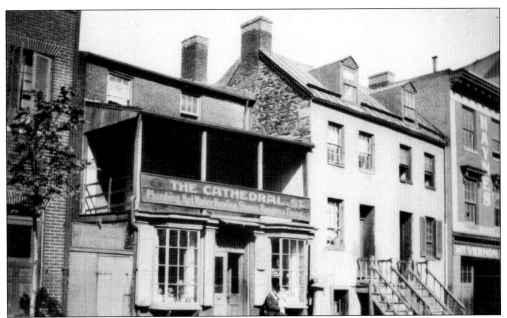

Laurence H. Fowler seems to have spotted something especially appealing in this row of buildings on Cathedral Street. He photographed it from at least three different angles. The house partly visible on the left, 1108 Cathedral Street, belonged to Henry Heinmiller, a carpenter. The building next to it was the store and possibility the residence of John M. Knight, plumber. Mount Vernon Motor Cars, at 1118 Cathedral Street, is partly visible at right. (Courtesy of the Enoch Pratt Free Library.)

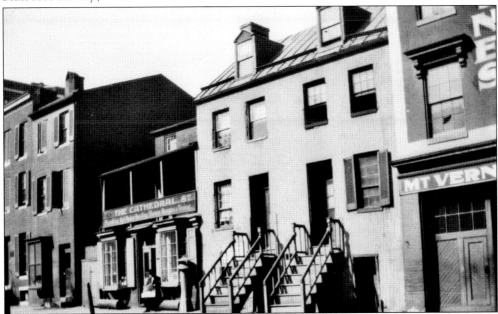

Six windows, only one of which has shutters, gape from their blank facade. It brings a note of intrigue to the otherwise straightforward building, as does the pair of sturdy wooden steps. One looks in vain for marble here. The second-story window of the Mount Vernon Motor Cars building has a broken pane: not a hopeful sign. (Courtesy of the Enoch Pratt Free Library.)

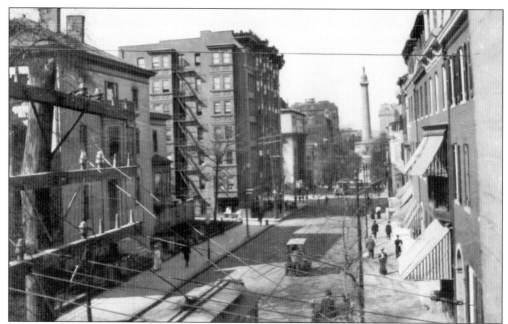

Laurence H. Fowler took this photograph of Charles Street looking north from his office on the third floor of 347 North Charles Street. Here the pace and temperament of urban life at the turn of the century are simply yet dramatically portrayed. The tangle of telephone wires, insulators, and pole are harbingers of a new and utterly transformative age. (Courtesy of the Enoch Pratt Free Library.)

This view of the interior of Laurence H. Fowler's office was taken around the turn of the century. The shades are drawn as if guarding against any external distractions. Photographs of buildings stand on a shelf, as if surreptitiously bringing the city to view. Fowler was a practicing architect. Among his better-known buildings is the War Memorial Building of 1921. (Courtesy of the Enoch Pratt Free Library.)

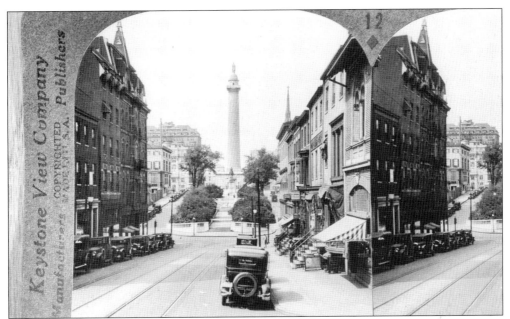

This stereo view of Charles Street looking north provides excellent details of the area. The St. James Hotel is at the intersection of Charles and Centre on the left. The awnings of the commercial buildings bring additional character to the scene. (Courtesy of the Enoch Pratt Free Library.)

This portfolio case yawns to display its contents in this photograph taken by Laurence H. Fowler of his office at the turn of the century. Carved about the doors is the comment that "much learning does not teach wisdom." Unfortunately the portfolio case doesn't tell us what does. Fowler, a scholar as well as architect, devoted a sizeable percentage of his earnings to the purchase of architectural books. He donated his collection to the Johns Hopkins University when he retired in 1945. It is considered among the finest such collections in North America. This may be a photograph of his gestating collection. (Courtesy of the Enoch Pratt Free Library.)

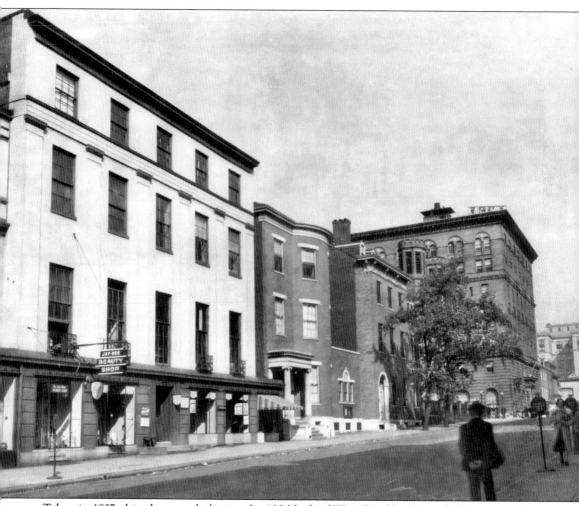

Taken in 1937, this photograph depicts the 100 block of West Franklin Street looking east. The YMCA building, First Unitarian Church, and the Standard Oil Building are visible in the distance. The Franklin Street Presbyterian Church is almost completely hidden by trees. The portico on the Frick House at the left as been removed, and the buildings have undergone an unsightly transition from residential to commercial uses. (Courtesy of the Enoch Pratt Free Library.)

A bus stops to receive passengers—whose feet can been seen waiting to board—in front of the YMCA building on the northwest corner of Franklin and Cathedral Streets. A Green Spring Dairy truck peeks behind it. It is an unremarkable image in most respects. But it gives the viewer some sense of the flavor of the street in the period around World War II. (Courtesy of the Enoch Pratt Free Library.)

These are some of the men who kept the buses and trolleys running. Look at the eyes; look at the hands. They speak of a deep and unaffected humanity. The men wear their attire with the dignity of princes. They possess a humanity and strength that remain unabated with the passage of time. (Courtesy of the Enoch Pratt Free Library.)

Rose Exterminating Company was around for a very long time. Judging by this example, it is debatable as to how heavily its advertising campaign contributed to its longevity. This rat—a picture of persistence, if not ferocity—looks as if he's nowhere near extermination. Perhaps that's the point. The Rose Man looks clearly outmatched, even with his fumigation device. The sweep of the tail is an amusing touch. The commercial artist seems to have been gifted with a (possibly subversive) sense of humor. (Courtesy of the Enoch Pratt Free Library.)

PEST CONTROL
SINCE 1860

"Call The
Rose Man"

S E C.
562
P.L.&R.

U.S. POSTAGE
AMOUNT
.01
PAID
P.B. METER 71140

Mr. Henry L. Mencken
1524 Hollins Street
Baltimore, Maryland
D

One can only imagine what force of time and chance conspired to preserve this card, addressed to H. L. Mencken around 1940, eight years before he suffered his debilitating stroke. Did he actually receive it? If so, why did he save it? Was he pestered by rats? E. A. Poe, had he lived to see the Rose firm established, would undoubtedly have been a more likely customer. In any event, it appears that history—rather churlishly, it must be noted—does not record whether "the Sage of Baltimore" ever deigned to discuss his exterminating requirements with "the Rose Man." (Courtesy of the Collection of William Hollifield.)

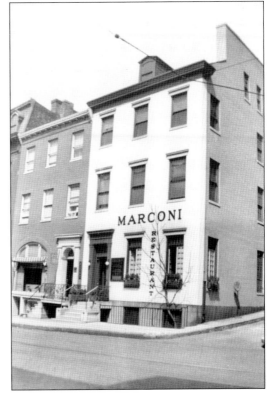

This photograph of Marconi's Restaurant at 106 West Saratoga Street was taken in 1940. By this time, residences were undergoing conversion to commercial uses. Fortunately, the owners seem to have felt no compulsion to radically disturb or alter the modest amenities of the building and indeed may have added a few touches of their own. H. L. Mencken courted his wife, Sara Powell Haardt Mencken (1898–1935), here. "All love affairs, in truth, are farcical," he wrote, "that is to the spectators." He noted that a man laughs four times in the course of an affair. "When one hears that the bridegroom, in revenge, is sneaking his stenographer to dinner at an Italian Restaurant, one laughs a fourth time." Perhaps he had this place in mind. (Courtesy of the Enoch Pratt Free Library.)

Abe Sherman at at least 90
Baltimore's best bookseller
starts each day a minitne

anniversary
Abe about as
well as you!

Emily Holloway

"The best thing about Baltimore? Our characters don't know they're characters." These words of Rafael Alvarez, member of *Baltimore Magazine*'s 2003 Best-of-Baltimore panel, speak an enduring truth—mostly. Judging from this 1986 photograph by Emily Holloway, Abe Sherman, voted Baltimore's all-time-best character by the panel, doubtless knows that he's a character. He started out as a corner newsboy before World War I and ran Sherman's Newsstand on the corner of Park Avenue and Mulberry Street for many years. Journalist Tom Chalkey, who worked there in the 1970s, calls Sherman "a tiny, white-haired specimen of living history." In this photograph, the history looks thoroughly distilled but only partly refined. He seems to have become a character in spite of himself. Known for his irascibility, he did not tolerate browsing, barking to the uninitiated, "If you want to read, go to the Pratt!" (Courtesy of the Enoch Pratt Free Library.)

AFTERWORD

Having meandered across the present and past of Mount Vernon Place, we turn to consider its future. On the whole, we do this with gratitude to previous generations who graced us with this inexhaustible legacy. Unfortunately more than this is required to sustain it. We must also exercise vigilance. This will inevitably mark the line separating joy from regret.

The potential effects of indifference are captured in the poet Philip Larkin's haunted and deeply felt elegy "Going, Going." Written in 1972, it is his poignant and personal rumination upon the England he had taken from granted from childhood, an England he now sees disappearing before his eyes: "The shadows, the meadows, the lanes, / The guildhalls, the carved choirs"—going or, in too many cases, already gone.

Will a future poet someday visit Baltimore to muse mournfully over the fate of Mount Vernon Place? "Most things are never meant," Larkin ruefully acknowledges, and yet they happen anyway. It is, he implies, the danger of unintentional carelessness rather than of malice that destroys a landscape, wrecks a city, or crushes a precious urban space. Whatever the motive, consequences can be deadly, and they often last forever. It is a lesson we learn with sorrow.

In Mount Vernon Place today, one discerns traces of departures everywhere, although, in most cases, they are tastefully and pleasantly disguised. The visitor's eye remains comfortably unperturbed. But however pleasing, Mount Vernon Place is no mere assemblage of facades. It does not exist only to entertain. Surely it cannot survive as a prop. Its best hope lies in recognizing that, at heart, it is a communal expression of real and intractable and enduring human concerns.

Springing without precedent from a singular conjunction of public and private imperatives, Mount Vernon Place has held on not only through the force of its inherent qualities, but also because generations have acceded to common vision and restraint, qualities that are rarely found together but which are increasingly necessary for our urban health. We hope this book, if nothing else, has helped to give the prospect a more palpable form.

After spending a full and productive career in the garment manufacturing business, Sam Boxley was not quite ready for full retirement. For nearly 15 years, he has operated the elevator at the Washington Apartments. He is shown here at the helm of his vintage conveyance. (Courtesy of Sam Boxley.)

Sam Boxeley poses with fellow servicemen in the 294th Army Company during Thanksgiving 1943 before embarking from San Francisco for New Guinea. Military service exposed him to a wider world than he had known in southwestern Virginia, leading to his decision to settle in Baltimore. "If a man cannot make a go of it in Baltimore," he contends, "he can't make it anywhere." (Courtesy of Sam Boxeley.)

This photograph shows Sam, third from left, enjoying a night out with friends, from left to right, Melvin Johnson, Ronald Baskerville, and Russell Gibson at Uncle John's Tavern sometime in the 1960s. They look ready and able to ignore the stern injunctions posted on the wall behind Sam's left shoulder. (Courtesy of Sam Boxeley.)

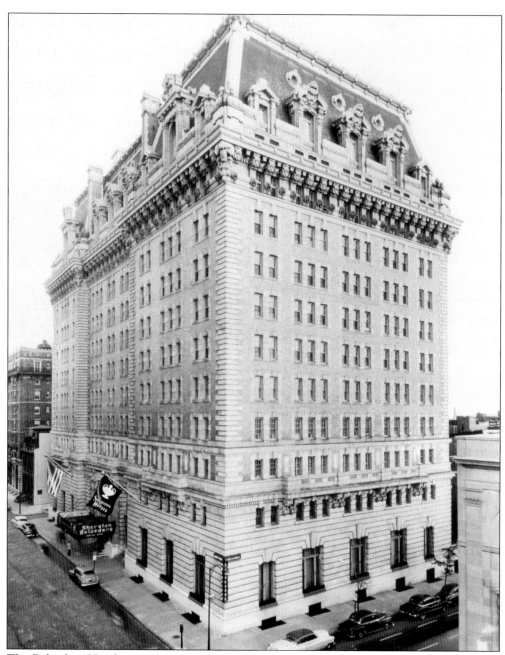

The Belvedere Hotel opened in 1903 to serve the social elite. It was designed by Parker and Thomas in a style that, according to a promotional piece written in 1943, "bridged the gap between the antique and the contemporary." This photograph shows the hotel in its new guise as the Sheraton-Belvedere Hotel in the early 1950s. The facade suggests that little has changed, but in reality, the clientele was shifting away from the purely elite. (Courtesy of the Enoch Pratt Free Library.)

This portrait of John Eager Howard was on display in the Belvedere Hotel. It was a copy of an original by Rembrandt Peale. A portion of the building stands on ground that had been part of Howard's estate. His residence, Belvedere, had once stood a few blocks south of the hotel but fell to the onrush of urban development. (Courtesy of the Enoch Pratt Free Library.)

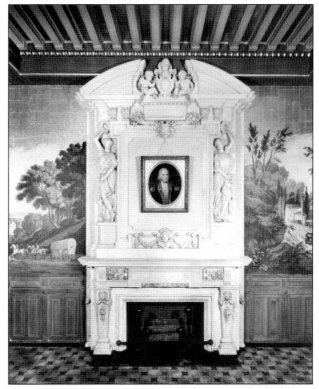

A promotional brochure marking the 40th anniversary of the Belvedere Hotel featured this publicity photograph of the grand ballroom decked out for a banquet honoring Queen Marie of Romania in 1924. The hotel's first banquet was held in January 1904, less than one month after the hotel opened for business. (Courtesy of the Enoch Pratt Free Library.)

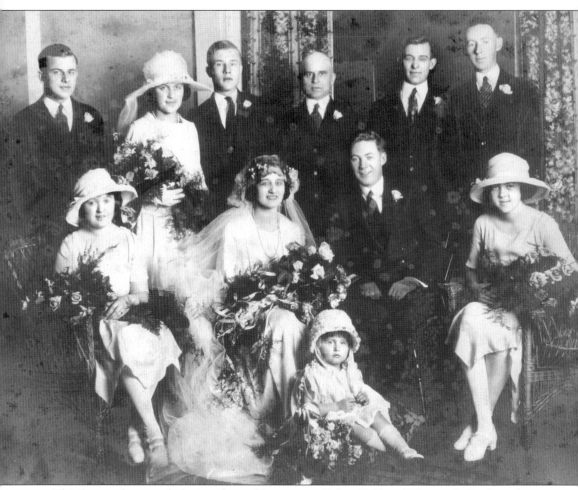

This festive photograph depicts the wedding party of Mary Hild and Thomas J. Guidera, shown seated in the center, posing at the reception at the Hotel Stafford in 1922. The distinguished gentleman standing behind the happy couple adds a note of sobriety to the event. Standing to the far right is John Guidera, best man and brother of the groom. Seated in the foreground is Marion Hild, a niece of the bride. (Courtesy of the Guidera Family Archives.)

The Stafford Hotel appears to enjoy pride of place in this photograph of the west side of Washington Place North. Dr. William A. Moale razed his residence to construct this building, which opened in 1894. Local builder William Ferguson was responsible for its construction. Bartlett Hayward and Company provided the structural and ornamental cast-iron work. The architect was Charles E. Cassell. The Graham-Hughes house is on the right; the Washington Apartments, designed by E. H. Glidden, is on the left. The apartments were completed in 1906. (Courtesy of the Enoch Pratt Free Library.)

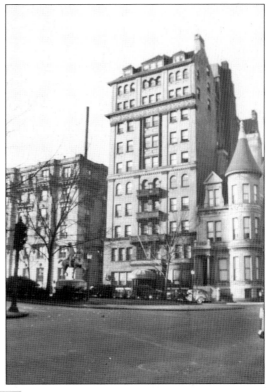

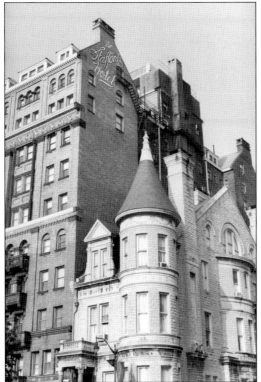

The painted script of the sign for the Stafford Hotel rises over the Graham-Hughes house on the southwest corner of Washington Place and Madison Street. The house was designed by George Archer (1848–1920) for George Graham, a member of the Brown family, and dates from 1888. It has the air of a folly and looks somewhat awkward in this space, seeming unaccountably stunted. Yet it retains its interest and remains among the most engaging buildings on Mount Vernon Place. (Courtesy of Bill Wierzalis.)

The early promotional literature of the Stafford Hotel was shameless. It used any and all means to induce the world at large to use its facilities. Someone in the organization must have concluded early on that it would make few sales by hiding its light under a bushel. In this illustration from a brochure, it touts its state-of-the-art ice machine and refrigerating plant. It notes that its new machinery avoided "the usual damp and musty odor that pervades refrigerators when cooled by melting ice." (Courtesy of the Enoch Pratt Free Library.)

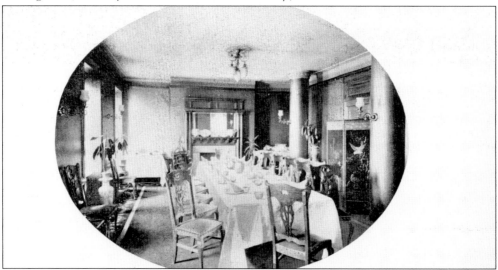

In this illustration of a private dining room at the Stafford Hotel, a chair is pulled away from the table as if beckoning the viewer and her party to a companionable meal. It is most likely that the American Psychoanalytic Association came into existence in such a room, as the founders met at the hotel on May 9, 1911, two years after Sigmund Freud and Carl Jung gave their lectures at Clark University. Recounting his experience there, Freud noted, "Thus even in prudish America one could, at least in academic circles, discuss freely and treat scientifically all those things that are regarded as offensive in life." Somehow, however, this does not appear to be the sort of venue where offensive conversation would be welcome. (Courtesy of the Enoch Pratt Free Library.)

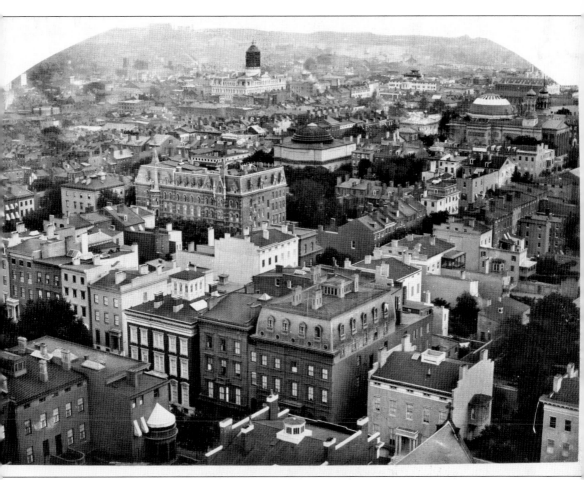

This is one of a series of panoramic photographs of Baltimore taken by local photographer William H. Weaver in 1873. Among the buildings portrayed here is the Garrett Mansion on West Monument and Cathedral Streets, lower left, and the St. James Hotel, center left near the dome of the First Unitarian Church. Ships line the harbor in the distance, upper left. (Courtesy of the Enoch Pratt Free Library.)

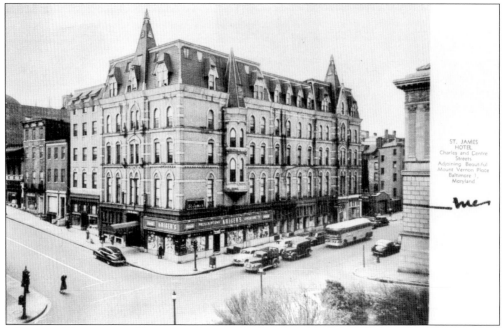

Like one of the imposing Victorian piles on London's Russell Square, the St. James Hotel offered more than respite to the hurried traveler. As this postcard from the 1940s suggests, it was scaled to its environment. It also interacted comfortably with the street. Perhaps this postcard was dropped in that mailbox shown on the southwest corner. (Courtesy of the Collection of William Hollifield.)

H. L. Mencken once observed that Americans have "a libido for the ugly." This housing project, built on the site where the St. James Hotel formerly stood, looks like the aftermath of the libido for the ugly working on steroids. As this photograph makes clear, it disdains the area; it disdains the street. In scale and intention, it rudely thumbs its nose. The Delano and Aldrich design seems to cower across the street. (Courtesy of Bill Wierzalis.)

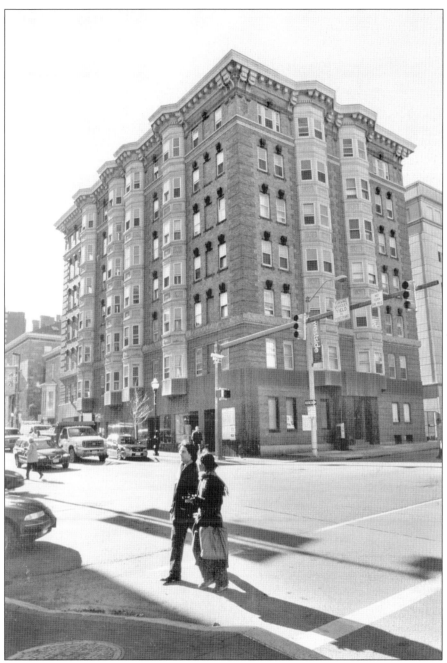

Given the name "Rochambeau" because the general's troops reportedly camped near here during the Yorktown campaign, this attractive, if undistinguished, building has become something of a cause célèbre. Its owner wants to demolish it. If this effort succeeds, it will complete a systematic destruction of the entire south side of the block of West Franklin Street between Charles and Cathedral Streets. The sterile structure to the right is a massive indoor parking garage, the sort of space that scorns its environs. Today the street level of the Rochambeau is virtually dead. But one cannot help but feel that only a minuscule portion of imagination and commitment could quickly revive it. (Courtesy of Bill Wierzalis.)

Welcoming as usual, Sam Boxeley holds the intricate iron door of the main entrance to the Washington Apartments facing Washington Place North, offering a partial glimpse of its elegant interior. It is a glimpse into an elegant past—not all that distant—which continues. It is also a portal to Mount Vernon Place's future, which will mean nothing if it fails to cherish and build on what the past has bestowed. Sam's wide and open smile tentatively assures the anxious that all will be well. (Courtesy of Sam Boxeley.)